# SECRET EVESHAM

## Stan Brotherton

AMBERLEY

First published 2019

Amberley Publishing
The Hill, Stroud
Gloucestershire, GL5 4EP

www.amberley-books.com

Copyright © Stan Brotherton, 2019

The right of Stan Brotherton to be identified as the
Author of this work has been asserted in accordance
with the Copyrights, Designs and Patents Act 1988.

ISBN 978 1 4456 8958 6 (print)
ISBN 978 1 4456 8959 3 (ebook)

British Library Cataloguing in Publication Data.
A catalogue record for this book is available from the
British Library.

Origination by Amberley Publishing.
Printed in Great Britain.

# Contents

Introduction 4

1. Before There Was an Evesham 10

2. Mysteries from the Abbey 16

3. Why Is Evesham Called Evesham? 20

4. Evesham by Any Other Name? 30

5. How to Say 'Evesham' 34

6. The Problematical Burial of Lady Godiva 38

7. The Cryptic Burial of Simon de Montfort 42

8. Secret Tunnels and Lost Silver Bells 47

9. Curiosities of the Churches 51

10. Puzzles of the Bell Tower 57

11. Why Did the Bell Tower Survive? 66

12. A Lost Bell of Evesham Abbey 70

13. Tales from Shakespeare's Evesham 76

14. Enigmas from Victorian Evesham 80

15. Alternative Eveshams 85

16. Selected Curiosities 92

Closing Thoughts 95

Acknowledgements 96

# Introduction

*Secret Evesham?* That's a tricky title; even a little paradoxical. After all, if this book contains any secrets, whatever they might be, then once you've read this book they won't be secret any more. If a secret is defined as 'something kept by a few and meant to be unknown or unseen by others'. then this might be a very short book (with a very small print run). So, if that definition doesn't work, how about something else?

In February 2002, Donald Rumsfeld, then US Secretary of State for Defence, made the following gnomic pronouncement:

> Reports that say that something hasn't happened are always interesting to me, because as we know, there are '*known knowns*'; there are things we know we know. We also know there are '*known unknowns*'; that is to say we know there are some things we do not know. But there are also '*unknown unknowns*' – the ones we don't know we don't know. And if one looks throughout the history of our country and other free countries, it is the latter category that tends to be the difficult one.

At first glance this might look like simple-minded nonsense (wrapping categories around ignorance), but there is something potentially useful here. Of the various categories proposed there are two of particular interest. The first is '*unknown knowns*', those things we don't know but, in reality, we really do (at least a little bit). The second is '*known unknowns*', those things we think we know, sort of, but know very little about (but we might be radically wrong). Incidentally, I think we can safely ignore '*unknown unknowns*' because, after all, who knows? Literally no one.

This, then, is a book about those things we might understand only superficially, including some things which might be very familiar. As Sherlock Holmes once observed: 'The world is full of obvious things which nobody by any chance ever observes.' In terms of secrets, it's not so much 'Shhh! Don't tell anyone' but rather 'Hey! Did you know?' For Evesham, this means curiosities, oddities, enigmas, mysteries, and history hidden in plain sight.

It is no secret that everyone keeps secrets. Governments have secrets (officially). People have secrets (naturally). Places have secrets (interestingly). Some secrets are trivial while some can be really rather serious (most obviously anything covered by the Official Secrets Act).

So, is there something especially secret about Evesham? For myself, I doubt it, but maybe. It seems unlikely because Evesham is a simple, picturesque, riverside market town tucked away in the heart of England. More than that, the history of the town seems pretty straightforward (that is, a 'known known'). In simple terms it goes something like this. First, before the founding by St Ecgwine of Evesham Abbey, around AD 700, there was

nothing here but scrubland. Then, once the abbey was established, an Anglo-Saxon town developed around Merstow Green. Over the centuries the abbey grew in importance; and so did the town. There were, occasionally, moments of terrible violence – most obviously the Battle of Evesham (4 August 1265) and the English Civil Wars (1642–51). Mostly, though, the history of the town is about growing prosperity based on agriculture and, much later, intensive market gardening.

Clearly, then, Evesham is not an obvious candidate for a place stuffed with secrets. There are, however, some little-known stories that are worth retelling, some local legends that need to be debunked, and some mysteries that are worth exploring.

Sometimes mysteries are elaborate fantasies with little foundation. A perfect example is the local tale that King Canute (often now spelled Cnut) lived in Bengeworth Manor. The origin for this tale appears to be the plaque attached to that ancient building, which states

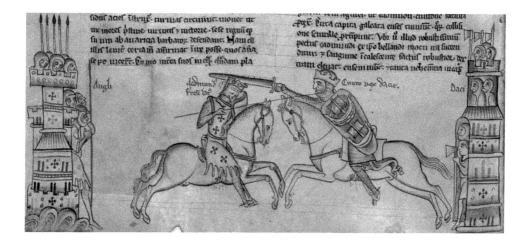

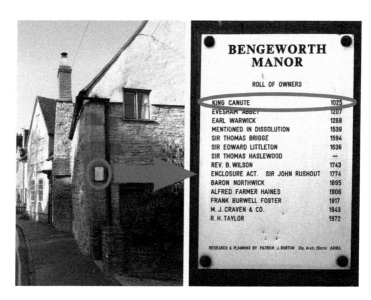

*Above*: King Canute was king of Denmark, England and Norway (the North Sea Empire). Here he is seen fighting Edmund Ironside.

*Right*: King Canute owned property in Bengeworth, but he did not live here.

that in around 1025 the manor was owned by Canute. It must be admitted that it's perfectly possible that Canute visited Evesham. Apart from anything else, Abbot Ælfweard (ruled 1014–44) was his kinsman. Additionally, Canute was very generous to the abbey, giving it estates at Badby and Newnham (Northamptonshire) as well as the relics of St Wigstan. If he ever stayed in the town, he would almost certainly have been an honoured guest of the abbot. More than this, Canute had extensive possessions throughout his realms, most of which he never visited because he was busy with diplomacy and war. Indeed, towards the end of his reign he styled himself 'King of all England and Denmark and the Norwegians and of some of the Swedes'. A very busy monarch, then, but was King Canute a resident of Bengeworth? The answer is 'no'.

Sometimes mysteries are actually mistakes. For example, in 1869 Edward Arber translated and edited a 1482 manuscript to produce *The Revelation of the Monk of Evesham*. The book provides a fascinating insight into medieval notions of purgatory and paradise. It does not, however, have anything to do with Evesham. Robert Easting, in his authoritative modern edition of the text, observes that early translators probably mistook 'in' as 'ui'; reading 'Euisham' (Evesham) rather than 'Einsham' (Eynsham, an abbey near Oxford). The proper title of this particular book is, in reality, *The Revelation of the Monk of Eynsham*.

Some curiosities are so commonplace that few folks question their origin. An obvious example is the coat of arms of Evesham. This appears all over the town, but what does it signify? The answer comes from 1604, when the town was granted a royal charter in the name of Henry, Prince of Wales and eldest son of James I (of England). Elements from the various arms of the prince were combined to create the town's then newly minted coat of arms. There is a prince's crown, a wheatsheaf (Earldom of Chester), two ostrich feathers (Prince of Wales), and a border of coins known as bezants (Duchy of Cornwall).

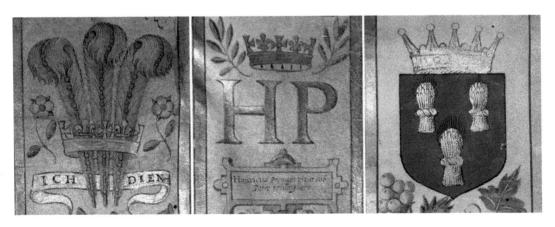

Selected coats of arms on Evesham's second royal charter, 1605. (VEHS)

Sometimes there's no mystery but simply quirky oddity. William Somerville (1675–1742) is remembered today (when/if he is remembered) for his extraordinary burlesque poem 'Hobbinol' or 'the Rural Games'. This poem is commonly believed to describe the Cotswold Games held on Dover's Hill, near Chipping Campden. A close reading, however, proves that the setting is actually Evesham:

King James I granting Prince Henry's petition for Evesham's second town charter (1605). (VEHS)

The town's arms appear occasionally on the town's street furniture.

In that rich Vale, where with Dobunian Fields
Cornavian Borders meet, far fam'd of old
For MONTFORT'S hapless Fate undaunted Earl;
Where from her fruitful Urn AVONA pours
Her kindly Torrent on the thirsty Glebe ...

... fair Nymph, Avona! on whose Banks
The frolic Crowd, led by my num'rous Strains
Their Orgies kept, and frisk'd it o'er the Green ...

'Hobbinol', Canto I (lines 13–17) and Canto II (lines 461–463)

Mention of the border between two Iron Age tribes – 'Dobunian' and 'Cornavian' – places the poem broadly in central England. Other details are more useful, notably 'rich Vale' and 'Avona' (i.e. the River Avon). The most telling reference is, of course, mention of 'Montfort', namely Simon de Montfort, Earl of Leicester, who was slain at the Battle of Evesham on 4 August 1265. What about the passing mention of the 'banks' of the river? Well, perhaps the overwrought mock-epic wrestling bouts described in the poem were fought in the Crown Meadow. If so, this would provide a pleasing link to the current day, as the Crown Meadow plays host to so many modern festivals and fairs.

Illustration from an 1813 edition of Somerville's mock epic 'Hobbinol' (set in Evesham).

As a young man Edward Elgar often visited Evesham and the Vale.

Another historical curiosity comes from Edward Elgar (1857–1934), an occasional visitor to the town. Early in his career (1878-81) he composed a five-minute piece, 'Evesham Andante', for wind quintet (oboe, clarinet, bassoon, and two flutes). There is no mystery here; it's just rather charming to find Evesham celebrated (if only slightly) by one of England's greatest composers.

This, then, is a book about mysteries, secrets, quirks, curiosities and oddities. The abiding idea is that the world around us is richer, subtler, more complex, and more thought-provoking than first impressions might suggest. The corollary of this is that careful consideration, contemplation, plus a little learning, can shed interesting new light on what might otherwise have seemed commonplace and conventional. How to do this? It's a question (ironically enough) of simply asking the simplest of questions, such as 'Why is it called that?' and 'Why is that there?' and 'Why is that like that?' The result, as it turns out, is to show that even an everyday town like Evesham contains mysteries and secrets tucked away, awaiting discovery.

# 1. Before There Was an Evesham

The story of Evesham starts with the Anglo-Saxons, but what was here before? Was there a 'Roman Evesham'?

There were certainly Roman settlements right across the Vale, including at Eckington, Pensham, Bricklehampton, Netherton and Cropthorne. Additionally, Roman flagstones and pottery (fourth century) have been found in North Littleton, while at Twyford evidence has been found of Romano-British roundhouses, gullies, ditches and animal shelters (second to third century). South of Evesham, just off the Cheltenham Road, are the buried remains of a Romano-British settlement complex (farmsteads, shops, workshops, courtyards and enclosures). For Evesham, though, within the loop of the river, only very limited evidence exists, largely comprising of small quantities of Roman pottery, a sestertius of the Emperor Trajan (ruled 98–117), some fragments of Samian ware, other pottery fragments, a Roman tile, and other bits and pieces. Not nothing, but not much.

Roman roads crossed the Vale. The most obvious surviving example in the Vale is 'Buckle Street', running from Bidford to Weston-sub-Edge. Furthermore, the alignment of Roman minor roads may be preserved in stretches of modern roads. There are also odd mentions, in old documents, of ancient roads such as 'ða fyrdstræt' ('the army road') in a remote corner of the parish of Bengeworth.

There is also intriguing evidence in selected local place names. A fine example is 'Bredon Hill', which combines three separate words each of which means 'hill'. The first element ('bre-') is Celtic/British for 'a hill or rising ground'. The second element ('-don') is Anglo-Saxon for a long hill. The third element ('hill') is, well, just the standard modern English word 'hill'. In a similar fashion we have 'River Avon', which combines two words meaning 'river'. In other words, the name 'River Avon' translates as 'river-river', while the name 'Bredon Hill' means 'hill-hill-hill'. Incidentally, the old name for the Battleton Brook is 'peodredan' (later 'Parret'), a Celtic/British word possibly meaning a 'river with five fords'.

A number of local places names contain possible Celtic/British personal names. For example, hidden away in the village name 'Chadbury' is the personal Celtic name 'Cædwalla'. P.H. Reaney, in *The Origin of English Place-Names* (1960), points out that:

> The existence in Old English [Anglo-Saxon] of such personal-names as Cædmon and Cædwalla, undoubtedly of Celtic origin, implies intermarriage and interfusion between the two races [British/Celts and Anglo-Saxons], presumably on a considerable scale, and therefore some degree of bilingualism.

Some place names are Anglo-Saxon but signify a surviving British population (that is the native people here before the Anglo-Saxon invasions). For example, the name

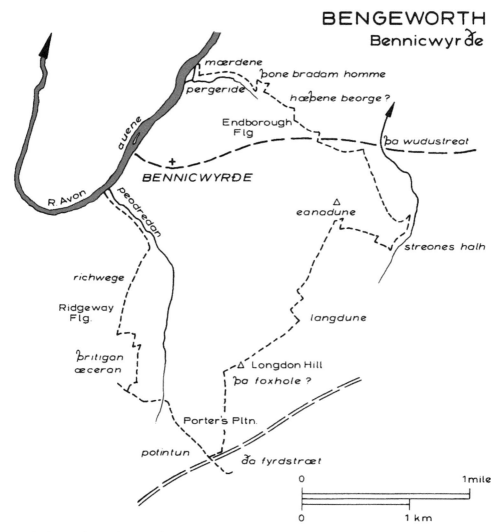

# BENGEWORTH
## Bennicwyrðe

mærdene

þone bradam homme

pergeride

hæþene beorge ?

Endborough Flg

þa wudustreat

auene

+

BENNICWYRÐE

R. Avon

peodredan

eanadune

streones halh

richwege

Ridgeway Flg.

langdune

þritigan æceron

Longdon Hill

þa foxhole ?

Porter's Pltn.

potintun

ða fyrdstræt

0          1 mile

0          1 km

Anglo-Saxon charter bounds for Bengeworth record fragments of ancient tracks and a possible Romano-British settlement at 'Potintun'. (Della Hooke, 1990)

Wellesbourne means 'stream of the Welshmen' (i.e. the British). In a similar fashion the village name Comberton might mean 'village of the British', while the village name Walcot (2 miles north-west of Pershore) denotes 'settlement of the British'. P.H. Reaney observes that: 'Place-names such as Walton ... suggest rather that British villages were sufficiently rare to be worthy of note.' Such names may be rare, but they are there. Della Hooke, in *The Anglo-Saxon Landscape* (1985), notes that such names indicate the presence of people still recognised as being 'of British stock':

The most common names are those derived from *walh*, 'a Welshman', later also applied to 'serf'. The numerous Waltons and Walcots are likely to represent settlements of people

still racially distinct at some time during the Anglo-Saxon period and many such names seem to have originated in the seventh or eighth century.

The earliest Anglo-Saxons apparently used the place name element 'wick' (from the Latin 'vicus' meaning a 'dairy farm or hamlet') to denote existing Romano-British settlements. According to Della Hooke (1985) village names that combine 'wick' with 'ham' (such as 'Wickhamford' and 'Childswickham') most likely signify a 'village near (or on) the site of a defunct Roman vicus'. Considering such evidence, Kenneth Cameron (1996) comments that:

> It has been shown that a significant number of the Wickhams and Wykehams are situated near to Romano-British habitation-sites and that there are too many examples of this for it to be purely coincidental. So, it is highly probable that here we have a group of names which has a direct connection with small Romano-British settlements.

The failed settlement of Poticot, on the edge of Bengeworth, may have developed from earlier Roman farmsteads. There are numerous signs of cultural overlap between the Anglo-Saxons and native British. The Anglo-Saxon kingdom of the Hwicce was ruled in the second half of the seventh century by Merewalh, a name meaning 'illustrious Welshman'. Additionally, at Stratford-upon-Avon, Roman coins have been found in the purses of Anglo-Saxon women as if those coins were still in use. There is also evidence of Celtic workmanship in artefacts found at a pagan Anglo-Saxon cemetery at Broadway. More than this, the kingdom of the Hwicce may have been of mixed Anglo-Saxon and British origin. Della Hooke (1985) remarks:

> The kingdom of the Hwicce appears to have obtained recognition early in the seventh century and it has frequently been suggested that the diocese of Worcester [in its earliest extent], formed in the mid-seventh century, represented most closely the territory of the kingdom it was formed to serve.

When the Angles and Saxons came to Britain they were not Christian but pagan. Large Anglo-Saxon cemeteries are found distributed evenly along the line of the River Avon, typically on good agricultural land in the more prosperous regions (such as the Vale of Evesham). There are many more Anglo-Saxon burials in the Avon valley as compared to the Cotswolds. There is mention in Bengeworth, in 1003, of heathen barrows near the north-eastern end of Longdon Hill. Christianity probably came to Britain with the Roman legions. Tertullian, writing in 208, recorded: 'In all parts of Spain, among the various nations of Gaul, in districts of Britain, inaccessible to the Romans, but subdued to Christ; in all these the kingdom and name of Christ are venerated.'

In 313 the Emperor Constantine issued the Edict of Milan, which made Christianity acceptable. Three of the thirty-three bishops at the Church Council at Arles (314) came from York, London and probably Lincoln. A little later, in 323, Christianity was the official religion of the Roman Empire. British bishops were probably present at the Council of Nicea (325), which formulated the still-used Nicene Creed.

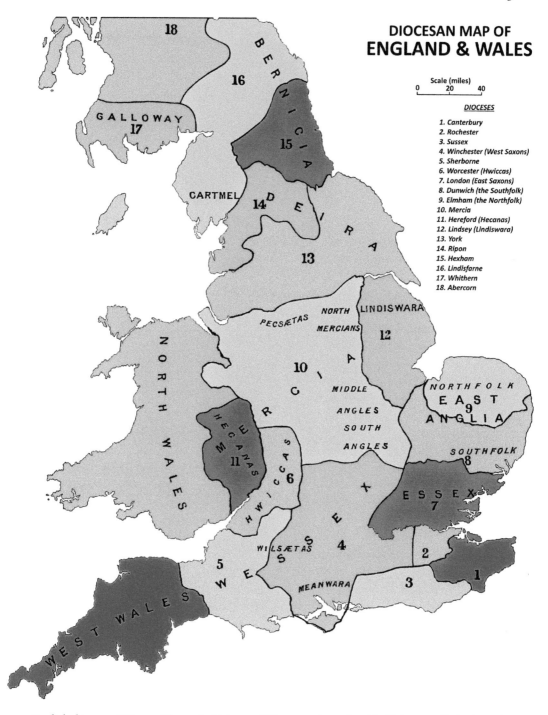

## DIOCESAN MAP OF
# ENGLAND & WALES

Scale (miles)
0    20    40

### DIOCESES

1. Canterbury
2. Rochester
3. Sussex
4. Winchester (West Saxons)
5. Sherborne
6. Worcester (Hwiccas)
7. London (East Saxons)
8. Dunwich (the Southfolk)
9. Elmham (the Northfolk)
10. Mercia
11. Hereford (Hecanas)
12. Lindsey (Lindiswara)
13. York
14. Ripon
15. Hexham
16. Lindisfarne
17. Whithern
18. Abercorn

English dioceses 668–737. The early bishops of Worcester bore the title 'Episcopus Hwicciorum'. The name Hwicce apparently survives in 'Wychwood' in north-west Oxfordshire.

DID YOU KNOW?
The meaning of the word 'Hwicce' has proved problematic. One early suggestion is that it meant 'ark or chest', perhaps in allusion to the shape of the Severn Valley bound by the Cotswolds and Malvern Hills. Another was that it meant 'cauldron or sacred vessel', this being a potential double allusion to the landscape and to a local cult. If the etymology is Brittonic, however, then 'Hwicce' probably meant something like 'the most excellent' and was presumably the name of a local ruling dynasty.

When St Augustine (Apostle to the English) came to Britain in 595, he found many thriving Christian communities. Celtic Christianity had survived both the Roman withdrawal (*c.* 400) and the Anglo-Saxon invasions. Indeed, claims have been made for Celtic antecedents for the nearby minsters of Deerhurst and Bredon, while two probable Christian burials (late fifth or sixth century) have been discovered beneath Worcester Cathedral. Della Hooke (1985) writes:

> The possibility of the survival of British Christianity in this area [the kingdom of the Hwicce] is difficult to assess. Christianity may not have been entirely abandoned in the region following the Roman withdrawal...

Intriguingly the conversion of the Hwiccian kingdom to Christianity is never clearly discussed by contemporary writers. This suggests, albeit tentatively, that there were established Christian communities. For example, before the conversion of the West and South Saxons, Queen Eaba 'had already received baptism in her own province of the Hwiccas' in the presence of her own Christian kinfolk. Additionally, an estate at Fladbury was donated around 695 to re-establish monastic life, and St Ecgwine reputedly received his early monastic education there. The kingdom of Mercia, which came to cover much of modern-day England, did not officially convert to Christianity until after the death of Penda in 654, but in the preceding centuries the practice of the Christian religion was not restricted.

Bearing in mind this context, we now come to a deeply intriguing detail as recorded by William of Malmesbury (*c.* 1095–*c.* 1143): '*Incultum antea et spinetis horridum, sed aecclesiolam ab antiquo habentem, ex opere forsitan Britannorum*', which translates into English as: 'It was once uncultivated country, rough, with thorn bushes, though there had been a little church there from olden days, possibly the work of the British.'

The description of the land as thorny scrubland suggests ragged woodland regeneration on abandoned farmland. More interesting, though, is mention of 'a little church there from olden days'. The word 'forsitan' (meaning 'possibly or perhaps') shows that the existence of this ancient church was an established fact, but its origin was uncertain. Intriguingly, the abbey charter records that Ecgwine, before founding the abbey, considered this place to be holy.

In summary, then, across the Vale we have a clear image of scattered Romano-British farmsteads, some Roman roads, plus established settlements. For Evesham, though, the picture is very sketchy. The evidence, what little there is, tentatively suggests a farm or estate somewhere near Upper Abbey Park with its own Christian chapel. So, was there a 'Roman Evesham'? At least for the moment there is no answer other than, perhaps, 'maybe'. Perhaps future archaeology will find a better answer?

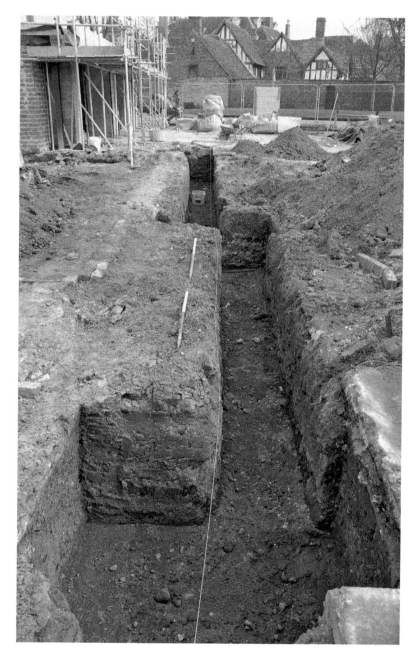

Archaeological work at the Vauxhall (Merstow Green) found evidence suggestive of substantial Roman structures within the vicinity of Merstow Green. The trench follows the line of new foundations. (Worcestershire Archive & Archaeology Service, © Worcestershire County Council)

# 2. Mysteries from the Abbey

Evesham's first abbot, St Ecgwine, is believed to have been a prince of the royal house of Mercia and a relative of King Æthelred. Apparently he was a zealous young priest who preached fervently to his heathen kinfolk. His talent was widely recognised, and in due course he was consecrated as the third Bishop of Worcester and, later still, became the first abbot of Evesham.

This is not the whole story, of course, as there's a fascinating tale attached to the arms of Evesham Abbey. This shows three mitres and a chain with a horse-lock. Behind these symbols is a particular story about St Ecgwine, retold here by local historian E. A. B. Barnard (1911) in the first volume of his *Notes and Queries* :

> He [Ecgwine] then becomes a great preaching Bishop, and fearlessly denounces the wickedness around him, and in consequence he of course makes many enemies, who accused him of being guilty of the very faults he blames in others. The exact nature of these charges is not known, but complaint was made to the King, and also carried to Rome and laid before the Pope, and he was commanded to make a pilgrimage to Rome to vindicate himself.
>
> In those days a journey to Rome was attended with dangers and difficulties, and an ordinary man would have thought the hardships by the way a sufficient penance; but Egwin [now more commonly spelt 'Ecgwine'], not content with the ordinary pains of pilgrimage, determined to have his legs shackled as became an accused man. The irons were placed upon the Bishop's legs and locked, and Egwin himself threw the key into the River Avon at Hurdingpool [a name of uncertain origin], close to the spot where in after years arose the stately Abbey of Evesham.
>
> He and his attendants embarked at Dover and in due time arrived at Rome; but at the Bridge across the Tiber, Egwin told his followers to wait there whilst he went to St Peter's to pray; saying also that they might occupy the time by fishing in the river. One of their number soon hooked a middling-sized salmon, and when the brethren were preparing the fish for supper they found within it the very key which Egwin had thrown into the Avon!
>
> Having released himself from the fetters, he at once presented himself before the Pope, and obtaining a full acquittal, returned home to be reinstated in his bishopric.

The importance of St Ecgwine is demonstrated by his relics being stored in a reliquary, the creation of a dedicated shrine, and the abbey's later dedication to both the Virgin Mary and St Ecgwine. The abbey church also housed the relics of other saints, including Credan, Odulf and Wigstan (the latter was also sometimes known as Wulstan or Wystan).

After the Norman Conquest (1066), Archbishop Lanfranc, contemptuous of Anglo-Saxon saints he had never heard of, had all such relics thrown into a fire. Those that survived

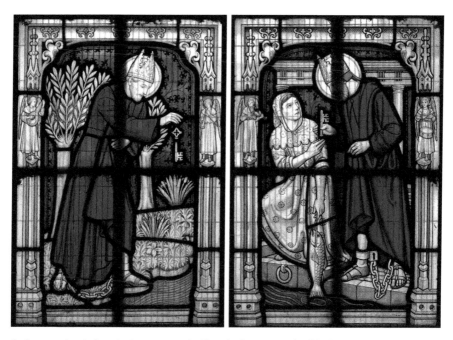

Details from stained glass in St Lawrence's Church showing a shackled St Ecgwine dropping a key into the Avon, and the later recovery of a key from the Tiber.

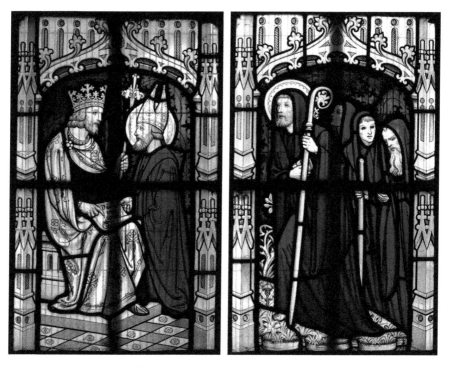

Stained glass in St Lawrence's Church. On the left, St Ecgwine receives a grant of land at Homme from Æthelred. To the right, St Ecgwine and three monks visit Homme, *c.* 701.

were declared genuine including the bones of St Ecgwine. Indeed, the restored relics were subsequently taken on tour to help raise funds to rebuild the abbey church. In the presence of these relics miracles multiplied, and the grateful faithful gave generously.

There were more than just saintly bones buried in and around the abbey. Other early burials apparently included two local kings: Kenred of Mercia (sometimes written Coenred) and Offa of Essex. There is some uncertainty here as, according to one source, Kenred and Offa went to Rome, laid down their crowns, became monks, ultimately died, and were buried in Rome.

DID YOU KNOW?

Dating the foundation of Evesham Abbey is tricky. However, the year of its consecration is clearly given in the grant of the first privilege by Pope Constantine 'written in the seven hundred and ninth year of our Lord's incarnation'. And when? On the Feast of All Saints, a date established in the West after 609/610 under Pope Boniface IV and dated to 1 November from the time of Pope Gregory III (died 741).

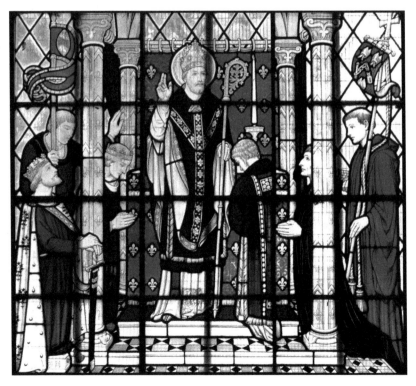

Stained glass in St Lawrence's Church showing St Ecgwine, now first abbot of Evesham, blessing the people in his abbey church. The banner on the left denotes 'Our Lady of Evesham', while the banner on the right bears the arms of the abbey.

So what happened to all these bones, holy and otherwise? Some relics were taken to other churches; for example, there is a report (dated 1817) of a cheek bone of St Ecgwine being found in Ramsey Abbey. At the Dissolution (1540), however, any reliquaries, with their relics, were certainly broken up, the ornamental gold and jewels sold and the bones discarded. Perhaps, then, under the soil in Upper Abbey Park and the abbey site are the finest traces of long-lost ancient kings and holy men.

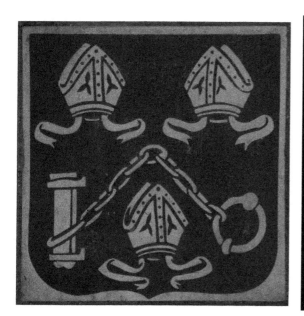 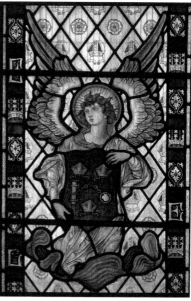

Arms of the abbey in a Victorian tile in the Lichfield Chapel and in stained glass (All Saints').

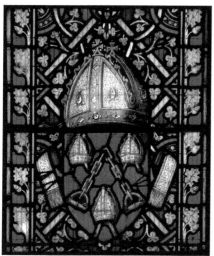 

Arms of the abbey in stained glass (St Lawrence's).

# 3. Why Is Evesham Called Evesham?

An obvious question: 'Why is Evesham called Evesham?' At first glance this might seem a wonderfully easy question, at least if you know the Legend of Evesham.

This story tells us that a swineherd named Eof witnessed a vision of the Virgin Mary at this spot, reported it to St Ecgwine (third Bishop of Worcester), who then visited the place, witnessed a similar vision, took it as a divine sign to found an abbey, and subsequently became that abbey's first abbot. That's the short version of the story. A longer version comes from the chronicles of Evesham Abbey, here as translated by Jane Sayers and Leslie Watkiss (2003):

At that time there was a place in the district of Worcester, overgrown with thickets and dense bushes, which these days is called Evesham, but then was known as 'Hethomme'. The man of God [Ecgwine] had desired this place, because it was there that he had thrown the key into the water. He therefore asked Æthelred, the king of the Mercians, for it and obtained it. Here he put herdsmen to maintain it for providing victuals for the servants of God. One of the herdsmen, called Eoves [actually Eof], who often saw many signs and wonders in that very place, one day saw there a brilliantly shining virgin who outshone the brightness of the sun by her own splendour. The virgin was holding a book in her hand, and with two other virgins was singing heavenly hymns. When the shepherd [actually swineherd] told his master, the blessed Ecgwine, of this, the man of God considered the matter quietly, turning it over in his mind that a proclamation was once made by an angel to shepherds that the Lord Jesus Christ had been born of a holy Virgin, and was shown to them in a crib. He did not think light of what he had heard from a lowly man, but, invoking the name of Jesus Christ with fasting and prayer, made it his very own business to investigate the story.

One day, therefore, after the night offices and vigils were over, at the first light, he took three associates with him, and made his way bare-footed to the place indicated; then, leaving his associates some distance off, he himself went further into the region, sat on the ground for some time, and with tears and groans prayed that by the intercession of His holy mother the Redeemer would show mercy. As he rose from prayer, three virgins appeared to him, no less splendid and glorious than previously. The virgin in the middle of these stood out taller, shining more brightly than the others, whiter than lilies, more verdant than roses, with a fragrance that could not be described: she carried in her hands a book and also a Cross which shone with a golden light. When Ecgwine realized that this was the Mother of the Lord, the virgin who surpassed all others, as if showing favour to him for his pious thoughts, blessed him with the cross which she held out as he worshipped her, and then, after a gracious farewell, she disappeared.

So it was that the holy man rejoiced over these things, understanding that it was the divine will that that very place should be preserved for the worship of God, and be consecrated to His blessed Mother for the redemption of the world. For he had once vowed amidst varied trials and temptations, that if the Lord would prosper his desire,

he would build a temple to the Lord. Hence, having now obtained through this sign the place already chosen by the blessed Mary through such a sign, he set it aside as the place to discharge his vow to God and the very Mother of God. He at once cleansed the place therefore from defilement, began the work appointed by God, and brought it to an honourable end, endowing the place also with many possessions obtained from the kings of England.

The Legend of Evesham tells us that the first part of the place name ('Eves-') comes from the personal name Eof; so the name of the town commemorates that original swineherd.

The meaning of the second part of the name ('-ham') has previously caused some confusion. One of Evesham's earliest historians, William Tindal (1794), thought that the original name of the town was 'Eovesholme'. He interpreted 'holme' as 'an island in a river' (an alternative might be 'flat land beside a river'). Tindal thought that, following cultivation of the land, the name was changed to 'Eovesham', with '-ham' now denoting a small town or village. While this might seem a rather attractive idea, it's simply wrong; early charters clearly say 'homme' (not 'holme').

Modern scholarship tells us that 'homme' (later '-ham') typically signifies an 'enclosure' or 'meadow', and in Worcestershire and Gloucestershire was commonly applied to land liable to flooding that stood beside a river (generally a promontory or the bend of a river). The name of Evesham, then, means something like: 'An enclosure within a river loop, liable to flooding, named after some bloke called Eof.'

In some old books Eof is called Eoves. Why? This question was definitively answered by O. G. Knapp (1920):

It is impossible that *Eoves* should have been the Swineherd's name for several reasons. In the first place the letter 'V' is not found in the Saxon alphabet, having been brought to

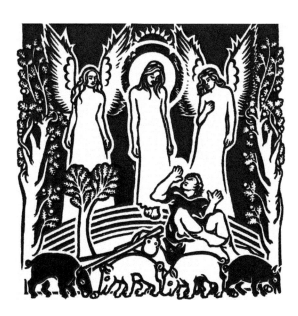

Pavement slab in Vine Street (installed in 2011) illustrating the vision of St Mary, plus two handmaidens, as witnessed by the swineherd Eof.

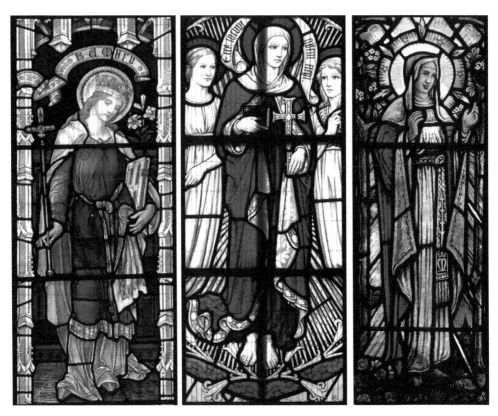

St Mary in stained glass. To the left, from All Saints' (labelled 'BV Mary'). In the centre, from St Lawrence's (labelled '*Ecce locum quem elegi*'), apparently bearing the face of Betty Goodall. To the right, from St Peter's (Bengeworth).

this country by the Normans; so that *Eofeshamme*, given in one of the charters, indicates the older and better form of the name ...

But even if Eofes is older and more accurate than Eoves it cannot be the original form of the name. A moment's reflection will show that if Evesham means the meadow of some person, the name of that person must be in what Grammarians call the Genitive (or Possessive) Case, Singular. This in modern English is nearly always denoted by *'s* placed at the end of the word; the apostrophe showing that a vowel has dropped out of the termination. Anglo-Saxon had a larger selection of endings for the Genitive Case, but the one in –es (the original form of our modern *'s*) belonged to what are called 'strong' Masculine nouns, which usually ended in a consonant.

Eofes, therefore, would be the natural Genitive of a man's proper name, Eof. Ferguson suggests that the original form of the name might have been Eofa, but such a name would correspond to the 'weak' nouns which made their Genitive by adding not –es but –an; in which case the name of the town would have been Eofanham, as is shown in the case of Offenham, the Ham of Offa or Uffa.

We may therefore take it as certain that the real name of the Swineherd was not Eoves, Eofes, or even Eofa, but Eof. And this is not a mere theoretical reconstruction, for Eof was

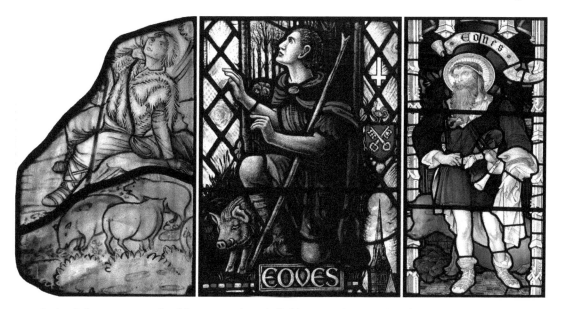

Stained-glass versions of Eof from St Andrews's (left), St Peter's (centre) and All Saints' (right). The central image also shows the inverted Latin cross of St Peter, a cockerel (Matthew 26:34), crossed keys (Matthew 16:19), and an image of the church.

actually a Saxon name. The Rev. C. Turner has found it borne by a Kentish priest who witnessed an agreement in 844 ... The form Eoves, though current for many centuries, is a mere blunder.

So what about Eof? What do we know about him? Very little, really, as it turns out. The abbey charter tells us that he was a swineherd who was known for his holiness and who 'often saw many signs and wonders in that very place'. And that, essentially, is all we know.

As an aside, the name Eof resembles the Kentish forms 'Iab' and 'Iof'. The name 'Iofes' is a form of 'Jove' or 'Jupiter' (namely the supreme deity of the Roman pantheon), while 'Iob' is the equivalent of either 'Jove' or 'Job'.

The swineherd Eof appears briefly in another early Evesham legend. This story says St Ecgwine acquired from King Æthelred a tract of thickly wooded land at 'Homme'. He divided this land into four sections and appointed a swineherd to supervise each section. The names of these swineherds? Well, in the east was Eof, in the south Ympa, to the west was Trottuc, and in the north was Cornuc. Each of these legendary names apparently relates to a geographical location. Eof is the name behind Evesham. Trottuc may be connected with Trotshill (formerly Trottuswelle) in Warndon, Worcester. The name Ympa may relate to Impney, in Dodderhill. Lastly, the name Cornuc may be the personal name behind 'Cronuchomme', an early alternative name for the place that became Evesham. It is interesting to speculate that the story of these four swineherds might, at least in part, derive from actual historical personalities.

Details of the Eof statue created by Worcester-born sculptor John McKenna.

The Eof statue in the Market Place was unveiled on 15 June 2008.

So, was there really someone called Eof? Perhaps; or, more likely, probably not. There is a strong chance that the Legend of Evesham, with all its fascinating detail, was developed to explain away why the town bore the name it did. In more technical language, the legend is a 'back-formation from the name itself'. The authoritative *Victoria History of the County of Worcester* provides the following damning verdict: 'Much of the story of the foundation of Evesham is doubtless the invention of the eleventh and twelfth centuries...'

DID YOU KNOW?

Nothing is known of St Ecgwine from early or contemporary sources. He is not mentioned by Bede or the Anglo-Saxon Chronicle. The abbey charter is attested by Ecgwine, and so is arguably contemporary, but Evesham Abbey had something of a reputation for forgery (whatever that might practically mean). Michael Lapidge, a world authority on Anglo-Saxon literature, has written that: 'The study of St Ecgwine and his foundation of the monastery at Evesham falls more clearly therefore in the domain of hagiography than in that of history.'

The Roman Catholic church (High Street) holds a statue of 'Our Lady of Evesham'. (Carmel Langridge)

The 1300th anniversary of the consecration of Evesham Abbey (709) was celebrated in 2009. Here Rt Revd Brother Stuart (abbot of Mucknell Abbey, 2001–17) is being beatified with a frisbee. (Andrew Spurr)

One of the many activities celebrating the 1300th anniversary was a pilgrimage, led by the Northumbria Community, from Evesham to Winchcombe on 11 April 2009. (Andrew Spurr)

So, did the vision really happen? The answer to that question rather depends on what you think of miracles. If you follow David Hume (1711–76) you will argue it's more rational to reject any miracle (defined as a violation or transgression of a law of nature). The Legend of Evesham, at least superficially, is radically improbable. More than that, it was seen by only two people (Eof then Ecgwine), at different times, with no third-party corroboration. Moreover, the monks who first recorded this story were neither impartial nor objective. Indeed, Michael Lapidge, international authority on Anglo-Saxon literature, noted in 1977 that 'Evesham is notorious for its forging of charters in the 11th and 12th centuries.' However, even a so-called 'forged' charter can contain true information and record established traditions.

If a supernatural explanation is not acceptable, but we accept that something did indeed happen (whatever it was), then perhaps there might be a subtle rational explanation? For example, in earlier ages food was often stored for long periods in damp conditions, and could therefore acquire 'interesting' moulds. Perhaps the Legend of Evesham was inspired by accidental hallucinogenics? Alternatively, perhaps it was the product of uncorrected eyesight? Perhaps both? Was the original vision simply a blurred mis-seeing, or hallucinogenic heightening, of something quite mundane?

If you have a more religious frame of mind, you might be more accepting of miracles. After all, St Thomas Aquinas defined a miracle as something 'done by divine agency beyond the order commonly observed in nature'. That is, a miracle is beyond common observation but not outside all observation. In other words, a miracle is improbable but not impossible.

Whatever we today might think of the Legend of Evesham, the monks of Evesham Abbey took it very seriously indeed. For them it had profound religious significance. The foundation legend demonstrated that the abbey had a divinely ordained legitimacy, a history pointing beyond the mundane, and a purpose rooted not in feudal power but the supernatural. Additionally, the miracle was not located in some misty remoteness, but here, in this place, in this immediate locality. Indeed, one tradition specifically places the vision at the top of Abbey Park. For those who worked for the abbey, or lived in the town, or visited as pilgrims, the Legend of Evesham was a source of reassurance that here, indeed, was somewhere special.

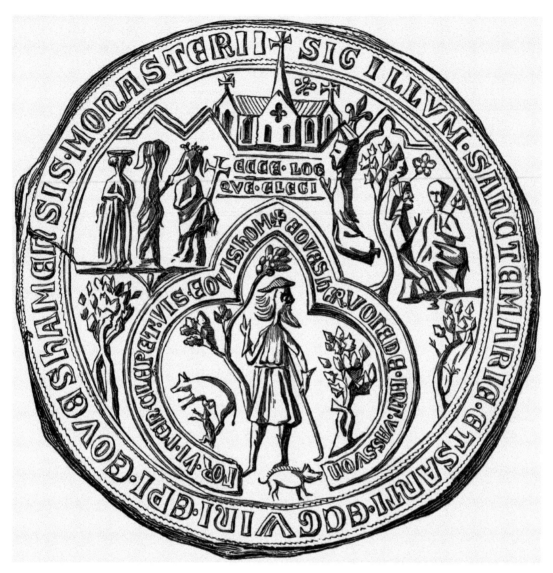

Obverse (front) of the conventual seal of Evesham Abbey, created in 1245–74 and used until 1540. The Latin script around the edge of the seal (circumscription) read clockwise from the top: 'SIGILLUM SANCTE MARIE ET SANCTI EGWINI EPI EOVESHAMENSIS MONASTERII'. Translated: 'Seal of the monastery of St Mary and St Ecgwine, Evesham'.

The English rhyme enclosing the large central figure (best estimate) read clockwise from the top: EOVES : HER : WONEDE : ANT : W[AS : SWON :] [FOR] : ÞI : MEN : CLEPET : ÞIS : EOVISHOM. This might be read as: 'Eof dwelt here and was a swain, which is why men call this Evesham'.

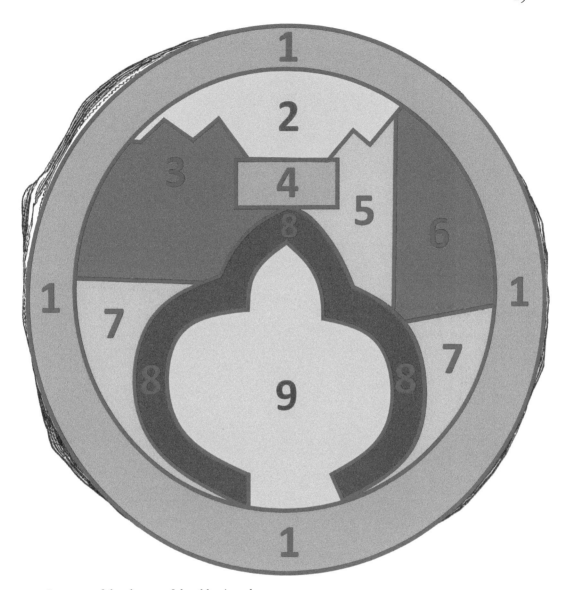

Structure of the obverse of the abbey's seal:
1. Circumscription in Latin stating that this is the seal of Evesham Abbey.
2. Model of a church.
3. St Mary (with cross) with two handmaidens.
4. Abbreviated Latin phrase 'ECCE. LOC. QUE. ELEGI' ('Behold the place which I have chosen')
5. A kneeling St Ecgwine presenting his model church to St Mary.
6. St Ecgwine communicates his vision to King Æthelred (an early benefactor).
7. Decorative trees (the area was then wooded).
8. An English rhyme explaining the name 'Evesham'.
9. Swineherd Eof with his pigs.

# 4. Evesham by Any Other Name?

Here's an interesting counterfactual question: 'Why is Evesham not called something else?' I think this a particularly fascinating question, not least because there are at least three credible imaginary alternatives: Cronucham, Merstow, and Egwinsham.

The first of these, Cronucham, is a modern reimagining of the Anglo-Saxon name 'Cronuchomme'. This appears occasionally in documents dating from 700 to 860. The first element of the name, 'Cronoc', might mean 'crane' or 'heron' but is more likely to be a Celtic personal name. Some writers, such as Tindal (1794), thought this was the former name of Craycombe (meaning 'crow valley') or, if not there, at least some place at some distance from Evesham. O. G. Knapp (1920), for his part, believed it was a spot (not necessarily inhabited) somewhere between the Twyford Bridge (now long gone) and the eastern boundary of Fladbury ('settlement of someone named Flæde'). There is, however, an authoritative answer. Della Hooke (1990), after a detailed examination of Anglo-Saxon charters, firmly identifies 'Cronuchomme' as a name for the land within the loop of the River Avon (modern Evesham). This is certainly the best answer because, as W. De Gray Birch (1882) comments (albeit a tad pompously): 'It is to the Saxon charter that the antiquary points to as to the highest and oldest native and authentic record of our insular history.'

Then there is 'Merstow'. The early Anglo-Saxon town, which grew up around the abbey, was centred on Merstow Green. The original name 'mære stow' means 'famous place' or 'holy place'. This locality was, then, distinguished, celebrated and holy. Although the word 'stow' primarily designates a locality, it also has a specialised sense denoting a religious purpose. The historian C. J. Bond (1973) observes:

> By reason of its more rudimentary plan and its closer integration with the abbey precinct, in a characteristic location on the western side of the main entrance outside the abbey *curia*, Merstow Green would appear to be the earlier [settlement] ... One curious reference in the *Chronicle* might lend support to this: when Abbot William de Chiriton builds the Great Gateway in the early fourteenth century this is described as 'versus villam' – facing 'towards the town'; in fact it looked out directly over the eastern end of Merstow Green.

What then of 'Egwinsham'? This is a modernised version of 'Ecguines hamme' ('Ecguine' being an alternative spelling of 'Ecgwine', which is sometimes spelt 'Egwin'), a place name that occasionally appears between 850 and 900. This is perhaps the most intriguing early alternative name. Its meaning is pretty straightforward, being something like 'the town of Ecgwine within a loop of the river'. Considering the absolutely fundamental role of St Ecgwine in the foundation of the abbey, and therefore to the existence of the town, it is odd that this did not become the final name of the town. O. G. Knapp (1920) observed:

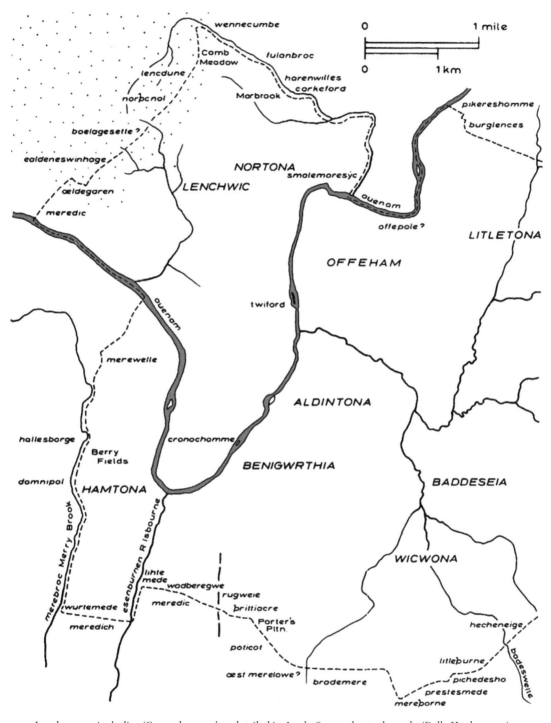

Local names, including 'Cronochomme', as detailed in Anglo-Saxon charter bounds. (Della Hooke, 1990)

It seems rather strange that such an obvious and appropriate name should never have come into general use; but apparently the Swineherd had taken far too firm a hold of the popular imagination to be ousted even by his master the Bishop, and the name died a natural death. Had it survived, its modern form might have been something not unlike Eynsham.

In its earliest days, then, this locality was known by a number of different names. Each one of these might have become the final and fixed form, but only one did. This town might have been called Cronucham, or Merstow, or Egwinsham, or Evesham. Three of these names recall Anglo-Saxon personal names (Cronoc, Ecgwine and Eof) while one

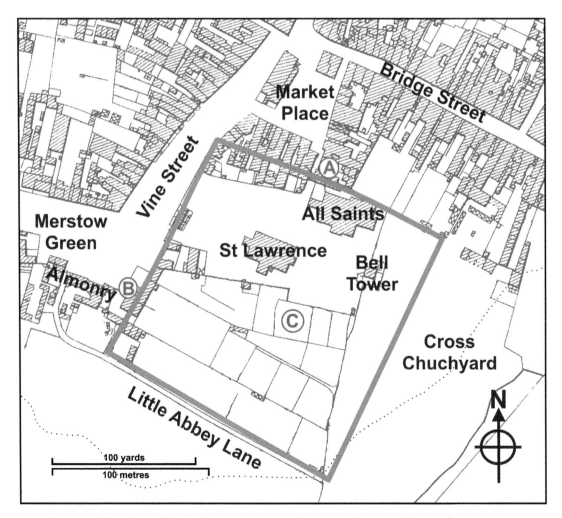

Conjectural boundary of the Anglo-Saxon minster: (A) graveyard gateway, (B) site of great gateway, (C) presumed site of pre-Conquest minster. (After D. C. Cox, 2015))

simply records the holiness of the site. In the end, though, it was the simple everyman swineherd who was commemorated.

Originally the name Evesham only applied to the land within the loop of the river. After that, with the granting of the second town charter (1605), the borough was extended to include Bengeworth. This place-name is an Anglo-Saxon compound of 'benge' and '-word' (meaning 'the farm or estate of the Benning, the son(s) of Benna'). The Anglo-Saxon word 'word' appears to have originally meant 'fence', then 'enclosure', then 'enclosure round a homestead', and finally 'homestead'. It was applied to places varying in size from 4 to 120 hides (1 hide equates to 30 modern acres) and sometimes to a small town or village. This place name element commonly occurs not in areas of early intensive agriculture, but in more wooded areas.

Hampton became part of the borough of Evesham in 1933. This relatively recent date is why some of the older residents (suspicious of such innovation) still consider it to be 'the independent republic of Hampton'. The name 'Hampton' comes from the Anglo-Saxon for 'high town' or 'high farm' (where 'high' means high up or elevated). The parish of Hampton is divided into two parts (Little Hampton and Great Hampton) by the River Isbourne. The river's name comes from the Anglo-Saxon for 'Esig's brook', a name memorializing the people who settled on its banks (the people of Esig or Esa). One variant from the twelfth century is 'Esingburna', signifying the stream of Esa's descendants.

The Legend of Evesham, miraculous or not, celebrates an everyman ('Eof' not 'Eoves'). In a similar fashion, other nearby place names recall the early Anglo-Saxon settlers to the area.

# 5. How to Say 'Evesham'

Having carefully considered the origins of the town's name we now come to a rather surprising question: 'How should one say Evesham?' Odd though it might seem, this question has arisen time and again. Why? Because the name is sometimes pronounced in unexpected ways. This matter was covered rather comprehensively in the *Evesham Journal* (3 April 1920) by O. G. Knapp:

It is therefore tolerably certain that the name of the town, after the Norman Conquest, would be pronounced *Ev-es-ham,* either with both *e*'s short, as in seven, or with the first *e* long, as in even. When the old spelling Eovesham was altered to Evesham to suit the new pronunciation, the orthography became fixed, and has never varied since. But if the spelling remained constant, the sound of the name did not...

The first thing to go would naturally be the aspirate, a sound which has always had a somewhat precarious existence in our Midland speech; and probably the change from *Ev-es-ham to Ev-es-am* would hardly be noticed.

Then the letter *v* has a trick of dropping out when it finds itself between two vowels, as in *sennight* for seven-night, *e'er* for ever, *e'en* for even, *deil* (in Northern English) for devil. When it disappeared the two short *e*'s left standing side by side in E-e-sam were bound to come together and produce the long vowel sound as it is heard in Evesham to this day.

DID YOU KNOW?
The local Evesham dialect (rarely heard these days) is known as 'Asum'. With many words surviving from long-lost Anglo-Saxon, when heard at speed it could be impenetrable (at least to outsiders). Some snatches of conversation: 'Aye-Aye, you! Ow bist? Fair to middlin, you... Wur ust thee bin lately? Waddus myun? Er yunt! It yunt theyrn, thee knowest: it's ourn.' From 1956 to 1983 the *Evesham Journal* published a series of mock-academic articles on this topic, all written under the pseudonym of Ben Judd. Who was this really? In 1983 it was revealed as the pen name of Charles William Clarke, editor of the *Evesham Journal* from 1961 to 1983.

Enlarged detail
from the road map
(1675) from London
to Montgomery
by John Ogilby
(1600–76). (VEHS)

At this point the process of decay was arrested; indeed, it could hardly go much further and leave any semblance of a name at all. But now came the reaction. At some period, which cannot be exactly determined, but which may be within the last two centuries, some people, probably belonging to the better educated part of the community, observing that the name of the town, though pronounced *Esam*, was spelt *Evesham*, set themselves to correct what they deemed a vulgar error, and to restore what they no doubt supposed was the correct pronunciation.

But like many other would-be restorers, they restored the name to a form it never bore, and in reforming one abuse, of course with the best possible intentions, only succeeded in perpetuating another and perhaps a worse one. For not knowing anything about the origin of the name, they wrongly divided the syllables, calling it *Eve-sham*, and so not only concealed the true derivation, but actually suggested a false and absurd one.

It is one of the cases which justify Mr Duignan's remark in the preface to his *Worcestershire Place Names*: 'A modern popular pronunciation is often of great assistance; the uneducated have been the preservers of Old English, the educated its main corrupters'... The comparatively modern sound of *Eve-sham* is 'a fond thing vainly invented' by would-be reformers, but is in fact a worse corruption than *Esam*, which though it may help to conceal the true derivation, does not suggest a false one.

This topic was picked up by Ben Judd in one of his many wonderfully amusing articles entitled 'More Asum Grammar' (*Evesham Journal*, 6 March 1964):

> The argument about the 'correct' pronunciation of '*Evesham*' ... will never be satisfactorily concluded by a victory for one school of thought over the others. There is no strictly definable authorised version, for the very simple reason that there is no strictly definable authority in the matter. For who is to lay down the law? ...
>
> What we have to consider is ... how the name 'Eoveshomme' was pronounced by the Abbot of Evesham, when that dignitary, one Aegelwy, himself an Anglo-Saxon and not a Norman, was asked by William the Conqueror's inspector of taxes to describe the monastic holdings ... Of course this is a tall order.
>
> Unfortunately there are no Anglo-Saxons left to tell us the answer; so we must use a little imagination, though not too much, and consult Henry Sweet. Now here it is only decent to place on record that the interpretation produced is subject to a bit of give and take. But if we take Henry Sweet's word for it that the Old English diphthongs were pronounced with the stress on the first element, then '*Eoves*' would more or less rhyme with '*Heave us*' as a native of modern Birmingham might say it – except that '*us*' (to complicate the situation a little further – and, for heaven's sake, why not, now we've got as deeply into it as this?) '*us*' would sound like '*uz*', as they say it in Manchester.
>
> '*Eoves*', then, sounds like '*Eva's*'. Something that belonged to 'Eof' (*Eef*) was 'Eoves' (*Eva's*). I fervently hope that this is now clear. If it is, we must at once proceed further to the realisation that the original sound of '*Eoveshomme*' had four syllables, for the final '*e*' was not silent until relatively recently in the history of English, and both '*m*'s were sounded. '*Eva's-hom-muh*'.
>
> After that rather dangerous but necessary incursion into the past of a thousand years ago, it will be easier to look at what happened when the language first levelled (in Middle English) and then lost (in Modern English) its inflexions. Professor Wrenn (in *Chambers's Encyclopaedia*, vol. V, p. 302 b) puts its simply: '... the placing of the stress-accent as near the beginning of the word as possible has tended to blur and often later to eliminate unstressed final syllables, which tend to be lost in rapid speech.'
>
> So we reach, by the time of Shakespeare perhaps, a stage of which Evesham has become '*Eva's-hom*', with three syllables and the stress on the first. It is still important to remember that the vowel sound in the stress-accent is not a pure, straightforward, modern '*ee*', as in tee-hee, tee-hee, if you should happen to feel like laughing in the old-fashioned manner. It is a sound rather nearer to the 'Yeah, Yeah, Yeah' of those distinguished young gentlemen from Liverpool [the Beatles], more power to their elbows, for they are doing more for the English language than any of the kitchen sink playwrights.
>
> Well, then, it follows that '*Eva's-shum*' possesses at least as respectable an ancestry as '*Eve-sham*'; so there is really no justification for being uppish with those who say '*Ee-vee-shum*', for they are only doing their best according to their lights.
>
> As for the common usage of the place, the people on the Badsey bus and those in the bar at the *Wheelbarrow and Castle* [Radford] know perfectly well, without the help of Henry Sweet, that there is only one acceptable way to pronounce the name 'Evesham'

and that is the way all honest swine-herds have, from Eof onwards, *'Asum'*. Here, at last, you have the correct vowel qualities, the correct stress-accent, and so much more that is down to earth and unpretentious. *Asum.*

'Asum' is the way those born and bred in Evesham used to commonly say the name. This pronunciation has a pedigree going back many centuries. Today, however, things have changed; pretty much everyone now pretty much says the name as it's written: 'Eve-shum'.

> 2. Evefham, or Efam. 7 miles S. E. of Worcefter, fituate on a gentle afcent from the river Avon, over which it has a ftately bridge of feven arches. It is a very ancient town, and enjoys many privileges.
> ...Near this town is a vale, called The Vale of Efam, efteemed the moft fertile in the kingdom.

> in process of time, this name assumed its present one of Evesham, which is now often abbreviated and pronounced Esàm.

The old way of saying 'Evesham'. At the top, from *The London Magazine* (1753); at the bottom, from E. J. Rudge's fascinating local history (1820).

DID YOU KNOW?
Plum Jerkum is a rough-and-ready alcoholic drink made with plums (in effect, the Vale's answer to rough cider). Commonly made using Yellow Egg plums (and drunk in half-pints) with no additional sugar and no added yeast. In simple terms, put 8 lbs of ripe unwashed fruit into a gallon of water, mash it up a bit (do not damage the stones), cover with a lid, leave to ferment for three months or so, rack off, wait a bit (a month?), then drink.

# 6. The Problematical Burial of Lady Godiva

There is one local legend that definitely needs to be debunked: the story that Lady Godiva is buried at Evesham. She was a very important and powerful lady: Countess of Mercia (fl. 1010 to 1067), wife of Earl Leofric and an important feudal lord in her own right. Both Leofric and Godiva were generous benefactors to monastic and other religious houses, including St Mary (Worcester), Leominster, Chester, Much Wenlock, Coventry and Evesham. Local historian E. A. B. Barnard (1911) wrote about the latter connection:

> It is not clear what first attracted their attention to Evesham, but when, after several visits, Leofric learnt from the monks that among the lands which he had received after the execution of his brother Northman [sic] were some which had formerly belonged to the Abbey, but had been lost in the Danish troubles [the Viking invasions], he at once took steps to restore them.
>
> Among these lands were Hampton, and it would appear Bengeworth, which the Abbey regained after many years' alienation. The restoration of this property seems to have been due to the influences of the Prior Avicius, or Æfic, previously mentioned as the brother of the Hermit Wulsin, whom Godgifu [Godiva] had taken as her Father Confessor; to whose persuasions indeed the Evesham Chronicler attributes the founding of Coventry and several other churches.
>
> The rents of Hampton were appropriated to a church which she and her husband had built and given to the Abbey in honour of the Holy Trinity, and which, in accordance with their usual custom, they further adorned with noble gifts. The Chronicler particularly specifies a large rood with its accompanying figures of the Blessed Virgin Mary and S. John the Evangelist of silver gilt, with vestments for the officiating priest.

DID YOU KNOW?
The Evesham Mappa Mundi ('Map of the World'), commissioned c. 1390, is a medieval map centred on Jerusalem and oriented with east at the top. At the very top of the map is an image of Adam and Eve encountering the serpent entwined around the Tree of the Knowledge of Good and Evil (the surrounding design echoes the Abbot's Chair). Not so much a travel guide, such maps were something more like a 'geography of Christian Being'.

*Right*: History paving slab (Vine Street), designed by Ned Haywood, repeating the common story.

*Below*: The abbey site, with allotment gardens, as seen from the top of the Bell Tower (2015). Was Lady Godiva's church of the Holy Trinity somewhere here?

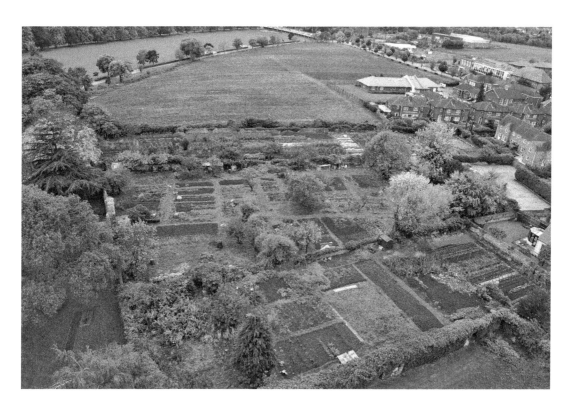

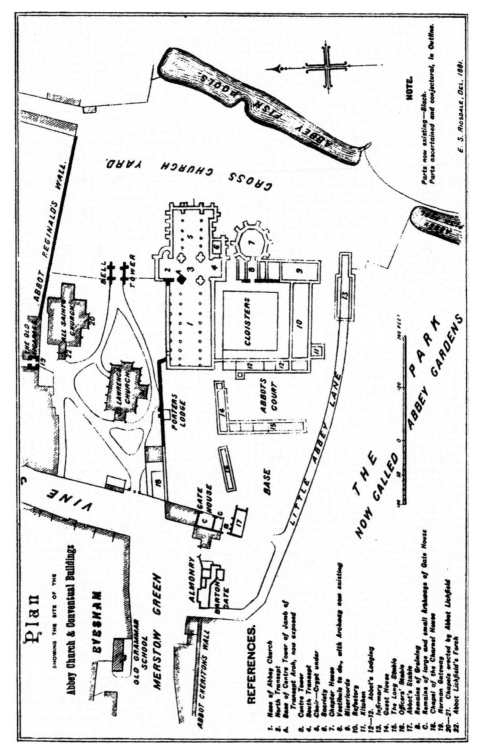

A radically speculative plan of Evesham Abbey by E. S. Ridsdale (1881).

One particular detail stands out – Lady Godiva's gift to Evesham of a new church dedicated to the Holy Trinity. So, where was this church? Well, it might have been in Bengeworth because the old church there, in Church Street, was originally dedicated to the Holy Trinity. Much more likely, though, is this suggestion by David Cox (1990):

> Since the new church was intended to enhance the abbey, it presumably stood near the abbey church. It may even have been structurally attached to the abbey church, either when originally built or as a result of some later enlargement of the abbey church towards it ... The fact that the Evesham *Gesta abbatum* do not record any subsequent demolition of Holy Trinity reinforces the suggestion that Holy Trinity was eventually, if not at first, attached structurally to the abbey church; when the abbey church was later replaced.

According to one local legend Lady Godiva was buried in her church of the Holy Trinity. Depending on where this church was located, this would mean she was buried either in Bengeworth or somewhere in the centre of Evesham. This story appears to have arisen from a single source, namely an entry in the index of the *Chronicle of Evesham Abbey* as edited by William Dunn Macray in 1863: 'Godiva, countess of Coventry ... buried in Trinity church.'

What are we to make of this? Well, the entry itself reads as follows:

> *Venerabilis igitur prior iste Avicius anno ab Incarnatione Domini millesimo tricesimo octavo ex hac luce discessit, et in eadem ecclesia sanctœ Trinitatis coram eadem religiosa comitissa Godgiva venerabiliter sepultus exttitit, cujus et memoriam habuit quam diu vixit.*

Macray's volume only includes the Latin text. However, in 2003 a definitive English translation was published:

> ... the venerable prior, Æfic, departed this life in the year of our Lord 1038, and was honourably buried in the same church of Holy Trinity in the presence of the devout Countess Godgifu [Godiva] who remembered him as long as she lived.

So, Macray's index says Godiva was buried in the Evesham church of the Holy Trinity, but the actual text says no such thing. Perhaps Macray was careless when preparing his index, or perhaps he (mis)read the Latin word '*coram*' ('in the presence of') as 'alongside' (as in 'buried alongside'). Whatever the source of the error, it is certainly an error.

Lady Godiva was present at Æfic's burial (1038), survived her husband's death (1057), lived through the Norman Conquest (1066), and died sometime before the Domesday Book (1086). She was almost certainly buried with her husband at Coventry.

There remains, however, a lurking question: 'Where are the remains of Godiva's church of the Holy Trinity?'

# 7. The Cryptic Burial of Simon de Montfort

Evesham is famous for the eponymous Battle of Evesham, fought on 4 August 1265, between armies led by Simon de Montfort (Earl of Leicester) and by Prince Edward (later King Edward I). This was the decisive battle of the Second Barons' War (1264–67). Such was the wholesale slaughter that Robert of Gloucester (*c.* 1260–*c.* 1300) described it as 'a murder of Evesham for battle it was none.' In a certain sense the Battle of Evesham was when national history came to town.

Local tradition asserts that Simon de Montfort was slain at the Battlewell (not far from where the Squires meets Greenhill). However, medieval chronicles report that his last stand was at 'Godescroft' (thought to be where Croft Road now meets Greenhill). Nevertheless, the Battlewell has attracted some curious stories. William Tindal, in his 1794 history of Evesham, recorded his own particular experience:

> One more circumstance, of rather a ludicrous nature, shall be mentioned; though it may serve only to excite a smile at the expense of the author's simplicity and easy belief – Some little time ago, certain labourers who had been employed in digging gravel near the Battle-well, reported that they had found the gravel, at some depth below the surface, stained and clotted together by streams of blood.

History paving slab (High Street) illustrating the Battle of Evesham (1265). No contemporary chronicle mentions bowmen or bows.

The report met little credit, nor did the author himself think it worthy of any notice. But passing by this pit, a few days after, the deception was so strong as, for a time, to make impossibility itself seem probable. About two feet deep, the gravel appeared not only clotted in the manner above-mentioned, but even the pebbles intermixed were stained with, what had every appearance of, *congealed blood*.

In a moment the five hundred and twenty-eight years that had intervened, seemed as nothing in his eyes. The impossibility that any animal substance could remain so long unchanged in the earth, was obviated by the extreme dryness of the soil. The weight which, it could not but be observed, this tincture gave to the gravel, either seemed no objection at all; or might be accounted for by fragments of broken armour.

In short, he felt himself in the state of a *theorist* who is resolved to see nothing in nature but what tends to the establishment of his *beloved system*, and carried several of these clotted masses home, as precious relics of the battle. A very little reflection served to dissipate the dream; and it was concluded, as is probably the truth, that some *ferruginous* or rather *ochreous* substance, intermingled with the gravel, and washed down by the rains, must have given cause to this phenomenon.

This very spot was also said to have miraculous properties, as E. A. B. Barnard (1911) reports:

The student of Evesham history will recall many instances in which the earth around the Battlewell at Evesham, and also the water of the spring itself, was claimed to possess miraculous powers of healing and the like, for several centuries after the death of Simon de Montfort at that spot. I had never heard until recently, however, that until a very little time ago – even within the memory of people still living – there was a belief that this water was very efficacious for weak eyes, and that people often visited the spring and took water away with them in order to bathe them therewith.

The remains of Simon de Montfort were initially carried from the battlefield on a rickety old ladder, covered with a ragged cloth, and buried in the abbey church. Not all of his body remained available for burial. His body had been viciously mutilated (a great dishonour). His head was cut off, and his genitals removed, and both were sent as trophies to Wigmore Castle. His hands and feet were also removed and sent away.

The mutilated remains of Simon de Montfort were initially buried in the choir of the Evesham Abbey. This was an area, covering some 40 square feet, that sat directly below the abbey's central tower. The choir already contained the tomb of St Wulfsin. The tomb of Simon de Montfort became a place of pilgrimage. Across England over 200 miraculous were ascribed to him.

A number of nobles argued that it was unfitting even for the mutilated remains of Simon de Montfort to receive a Christian burial. After all, he had been under sentence of excommunication and was infected with the 'leprosy of treason'. The peace treaty of October 1266 stipulated that:

... the lord legate shall absolutely forbid that Simon, earl of Leicester, be considered to be holy or just, given that he died excommunicate according to the belief of the Holy

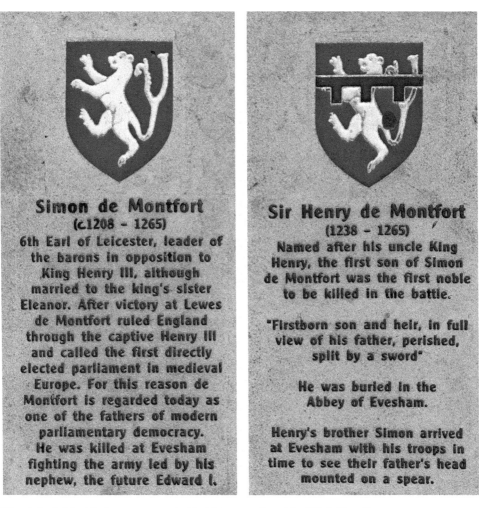

**Simon de Montfort**
(c.1208 – 1265)
6th Earl of Leicester, leader of the barons in opposition to King Henry III, although married to the king's sister Eleanor. After victory at Lewes de Montfort ruled England through the captive Henry III and called the first directly elected parliament in medieval Europe. For this reason de Montfort is regarded today as one of the fathers of modern parliamentary democracy. He was killed at Evesham fighting the army led by his nephew, the future Edward I.

**Sir Henry de Montfort**
(1238 – 1265)
Named after his uncle King Henry, the first son of Simon de Montfort was the first noble to be killed in the battle.

"Firstborn son and heir, in full view of his father, perished, split by a sword"

He was buried in the Abbey of Evesham.

Henry's brother Simon arrived at Evesham with his troops in time to see their father's head mounted on a spear.

The slain de Montforts commemorated in history paving slabs (High Street).

Church. And that the vain and foolish miracles attributed to him by some people in our land, shall not at any time pass any lips. And that the lord king shall agree strictly to forbid this under pain of corporal punishment.

The monks, obedient to the king's command, removed the remains. The Annals of Osney (c. 1277) report that the body of Simon de Montfort was 'exhumed, and thrown down in some [unconsecrated?] remote spot; which place is, to this day, hidden and unknown, except to a very few people'.

Amaury de Montfort, horrified at the treatment of his father's corpse, loudly asserted that his father had received absolution before the Battle of Evesham, had died wearing the penitent's hair shirt, and had given many signs of repentance before his death. The papal legate to England, Ottobuono, carefully investigated this matter (not least because it involved the eternal soul of a popular rebel).

In 1268, at a general council of prelates held in London, Ottobuono asserted that the Pope had absolved Simon de Montfort and all those killed with him. Additionally, he proclaimed that the Roman curia had been deceived in the sentence of excommunication. The upshot of all this was that Simon de Montfort's remains could, and should, be reburied in hallow ground. But where?

A visitor to the town might think this question to have the simplest of answers. After all the Simon de Montfort Memorial, unveiled in 1965 on the approximate site of the high altar, declares the following:

HERE WERE BURIED THE REMAINS OF
SIMON DE MONTFORT, EARL OF LEICESTER
PIONEER OF REPRESENTATIVE GOVERNMENT WHO WAS
KILLED IN THE BATTLE OF EVESHAM ON AUGUST 4th 1265

Given the stark political climate, and the sharp interest of the king, burial at the high altar is deeply unlikely. After all, this spot was the most important place in the entire abbey complex. Christopher Daniell, in his authoritative *Death and Burial in Medieval England 1066–1550* (2005), reports:

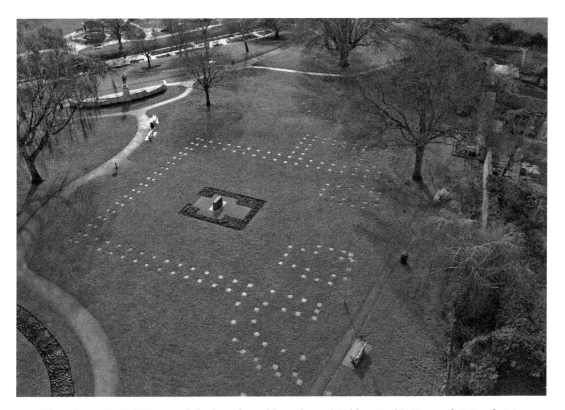

View from the Bell Tower of the long-lost abbey chancel (Abbey Park). Simon de Montfort is believed to be buried somewhere in this area.

There were also vertical boundaries between Heaven and Earth. In medieval Christian terms this is symbolically represented by burial as close as possible to the high altar or a shrine. These places had the power to draw down holy influence from Heaven, which was sometimes represented in art by a ray of light. A burial under the feet of the priest by the high altar was on a direct vertical line to Heaven.

So, if not there, then exactly where? The simple answer is: 'We don't know!'

Arguably the best speculative solution, as proposed by David Cox (2018), is that the mutilated remains of Simon of Montfort were ultimately laid to rest in the crypt, under the chancel, in consecrated ground, hidden away from public view. If so, then his bones may not be too far from the Simon de Montfort Memorial. But if so, then exactly where? And if there, could they be recovered?

The popular Elizabethan ballad of the 'Blind Beggar of Bethnal Green' tells the story of Henry de Montfort: left for dead at Evesham and rescued from the battlefield by a baron's daughter. This story is almost certainly untrue. This chapbook (1715) frontispiece is probably a repurposed image of Prince Rupert (1619–82) and his dog.

# 8. Secret Tunnels and Lost Silver Bells

There is a particularly persistent local legend regarding the abbey, a story of secret tunnels and lost silver bells. This topic was discussed in an letter from T. E. Doeg (16 February 1907):

> It seems a pity that the subterranean passage, which is said to have extended from the Evesham Monastery to Badsey, should not be thoroughly explored; for even if nothing of special importance was found in connection with it, it would be interesting to verify its existence, and trace its source. This is said to be by way of a passage starting from the old Abbey cellars now existing under the house in the corner of the Merstow Green, now known as 'The Abbey' [now known as Abbey Gates]. From thence it is supposed to pass under the river, and has an opening into the cellar of the Mansion House in Bengeworth, which is believed to have been a convent for nuns connected with the Monastery, and from which the tunnel is said to be continued to Badsey, where it terminates in the cellar of a house occupied by Mr Wilson.

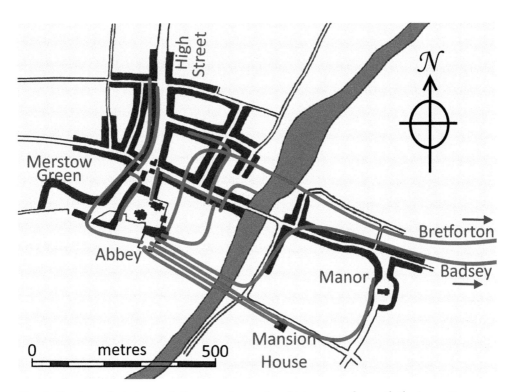

Map indicating selected speculative secret tunnels said to run underneath the town. Some are simply neighbouring cellars and underground storage.

This prompted the following response from O. G. Knapp (9 March 1907):

> Mr Doeg rather strangely omits the detail which might afford the strongest incentive to an excavator – I mean the peal of silver bells which are deposited in the passage under the bed of the Avon and which still chime for the midnight Mass on Christmas Eve.

DID YOU KNOW?
Apparently there is at least one modern secret tunnel quite close to Evesham. It is said that under Wood Norton Hill, and part of the BBC's training complex, there is a fully functioning nuclear bunker built in 1966, complete with sleeping quarters, larders, kitchens, broadcast equipment and ping-pong tables. The purpose of this secret base? Well, in the case of a nuclear attack, at least until 1993, according to rumour, it would have broadcast over 100 days of pre-recorded tapes to the nation; including comedy, drama, religious programmes and *The Sound of Music*.

There are a number of problems with the notion of lost silver bells. First, silver is a terrible metal for bells; it's far better to use an alloy of copper and tin (in the ratio 78:22). Second, there are no reports of mysterious bells ringing at special times. For myself, I have attended midnight Mass at All Saints' Church almost every year since I was a child, and every year I have listened for those elusive bells and never heard anything other than the sonorous tones of the Bell Tower tolling out midnight.

Perhaps, then, these mysterious lost silver bells were actually hand bells? Perhaps they had a silvery sound, or perhaps they had a silvery sheen? It's possible, but we have no way of knowing.

There are more profound problems with the notion of a secret 'under-river' tunnel. Most importantly, there's no evidence of a tunnel on either the Evesham or the Bengeworth side of the river (though there were drains). Additionally, such a tunnel would be wildly expensive, madly impractical and would need constant pumping to keep it clear of water. Moreover, there's no evidence of spoil heaps and no relevant mention(s) in the abbey chronicles. Furthermore, there was no need for an 'under-river' tunnel as there was already an 'over-river' bridge. Finally, there was never a nunnery in Bengeworth (or, indeed, in Badsey).

There are so many problems that it begs the question of why this local legend exists, let alone persists. First and foremost, I think, is the romantic appeal of hidden mysteries. Second, though, is the sly mention of a nunnery. This little detail clearly implies that the monks were 'all too human', not only prone to vice but systematically violating their vows. This implies, by extension, that the abbey was nothing special and that its dissolution was justifiable.

Discussions about the dissolution of Evesham Abbey are often tinged with a certain romantic regret. Many follow the example of E. A. B. Barnard who described Abbot Clement Lichfield (1514–39) as the 'last true abbot' and his successor, Philip Ballard, as a 'pseudo-abbot' (1539–40). These are intriguing labels that have, upon close examination, tricky political implications.

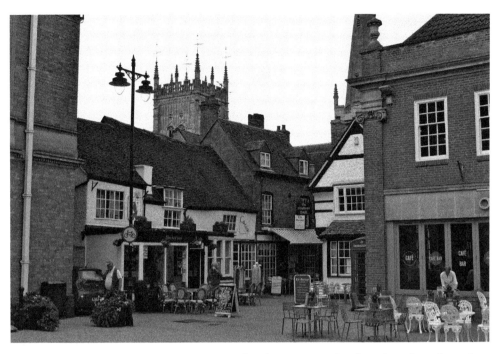

A series of linked cellars are said to run under the eastern side of Market Place through to Church House.

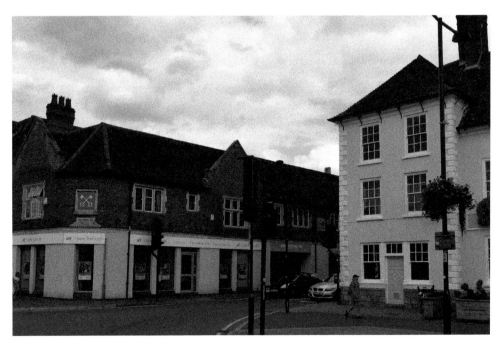

A door links the cellars of the 'Old Swanne Inne' (on the right) with those of the 'Cross Keys' inn (on the left).

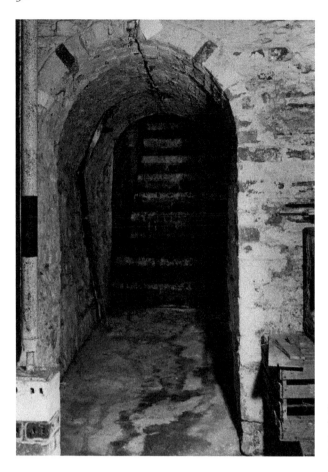

One of the well-built cellars
underneath the Alley (*c.* 1965)
now known as Allée de Dreux.
(VEHS)

Parliament passed the first Act of Supremacy on 3 November 1534, declaring
King Henry VIII and his successors to be the 'only supreme head on Earth of the Church
of England'. The act did not confer this sovereignty but instead acknowledged it as an
established fact. This moment marked the break with the Pope and the Roman Catholic
Church. Election to the office of Abbot of Evesham was traditionally confirmed by the
Pope (and, since *c.* 1215, only by the Pope). Once the Act of Supremacy (1534) was passed,
this step was no longer possible. Indeed, according to English law, this step was not
necessary. All of this means that the claim that Abbot Clement Lichfield was the 'last true
abbot' is, implicitly and perhaps unknowingly, a claim of continuing Papal supremacy.

The dissolution of Evesham Abbey is an extraordinary moment; by turns historic,
tragic, dramatic, and poignant. It is hardly surprising that it causes such fascination,
including curious local legends and romanticised remembrance.

# 9. Curiosities of the Churches

If you stand in the parish churchyard, in the heart of Evesham, and look around, there is an incredibly obvious question to ask: 'Why two churches?'

One explanation, often repeated, is that the two churches served different types of congregation, with All Saints' for the townsfolk and St Lawrence's for the pilgrims. In support of this view is the observation that the side aisles of St Lawrence's are (unusually) the same width as the central aisle; suggesting altars positioned around the church at which votive masses could be said. However, rather than a church, surely pilgrims would have visited the impressive neighbouring abbey with its multiple altars, multiple shrines, and the holy relics of ancient saints?

Another explanation, one proposed by Pevsner in *Worcestershire* (1968), is that the two churches had different functions. In this interpretation, All Saints' was the church of the parochial cemetery (an unusual function) while St Lawrence's was the parish church. This idea is supported by very little evidence. Indeed, when a revised and expanded edition of *Worcestershire* was published in 2007, this notion was dropped in favour of a further explanation:

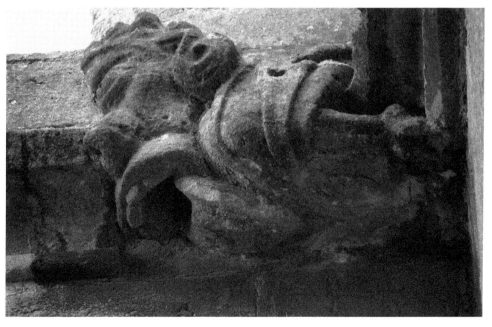

Gargoyle 'absorbed' into the stonework of the north-east corner of the Lichfield Chapel (built *c.* 1510) of All Saints' Church.

All Saints' grotesques carved in the 1970s. To the left is depicted Rt Revd Robin Woods (Bishop of Worcester, 1971–82) and to the right Canon Albert 'Bertie' Webb (vicar of Evesham, 1966–87).

> The curious thing about them [the town centre churches] is that they both stand within the Abbey precincts. This has never been fully explained: All Saints seems to have been the parish church for east part of the town, St Lawrence for the west.

This third explanation is supported by a lot of evidence, going as far back as John Leland and his *Itinerary* (1535–43): 'There be within the precincts of the abbey of Eovesham two parish churches, whither the people of the towne resort.'

Although there were two parish churches, from at least 1647 there was only one priest (often performing services alternately in each church). The situation became more complicated in 1730 when roof repairs to St Lawrence's went horribly wrong: the roof collapsed and the church was left largely derelict. Despite such ruin, St Lawrence continued as a parish church. The *Monasticon Anglicanum* (1819) records:

> The parish churches are still standing ... One of them is dedicated to All-Saints, and the other to St Laurence ... One of them, viz. St Lawrence, is officiated in the morning, and All-Saints in the afternoon all the summer season; but in winter-time there is very rarely divine service perform'd in St Laurence's church, that of All-Saints being only frequented.

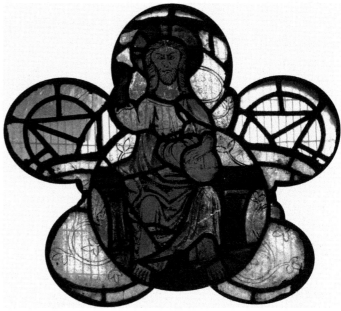

*Above left*: In the angle between the chancel and the south transept of All Saints is a (now blocked) squint lancet. This might have served as a leper's squint, a small exterior window through which the altar could be seen.

*Above right*: At the top of a stained-glass window in the north aisle of All Saints' is a fragment of fourteenth-century glass showing 'Christ in Majesty'.

To all intents and purposes, then, St Lawrence's was appended to All Saints'. Certainly that is how Samuel Lewis describes the situation in 1831: 'The living of All Saints' is a discharged vicarage ... The living of the parish of St Lawrence is a perpetual curacy, united to the vicarage of All Saints.'

This situation persisted, as George May observed in 1834:

> The parishioners of St Lawrence, who have suffered their own church thus to fall into decay, are at present accommodated in that of All-saints, and mingle with the parishioners belonging thereto. Distinct parochial meetings for the former parish are likewise held therein.

The Church of St Lawrence was restored in 1836/37. The then vicar, Revd Marshall, described himself as incumbent of a 'united parish'. He also produced separate returns for each parish and referred to both churches as parish churches. In effect, then, Evesham was managed as a single benefice with two parishes (and two functioning parish churches). This situation continued until 8 December 1977 when St Lawrence's was declared redundant. In the following year the church was vested in the Redundant Churches Fund (since 1994 called Churches Conservation Trust) and on 1 January 1978 the parishes of All Saints' and St Lawrence's were formally united.

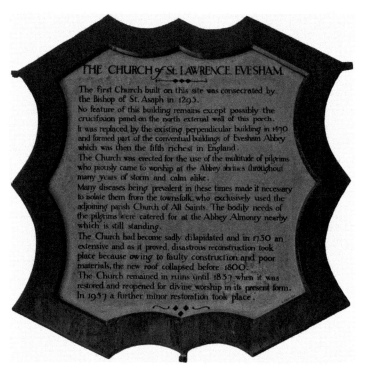

THE CHURCH of St LAWRENCE. EVESHAM.

The first Church built on this site was consecrated by the Bishop of St. Asaph in 1295.

No feature of this building remains except possibly the crucifixion panel on the north external wall of this porch.

It was replaced by the existing perpendicular building in 1470 and formed part of the conventual buildings of Evesham Abbey which was then the fifth richest in England.

The Church was erected for the use of the multitude of pilgrims who piously came to worship at the Abbey shrines throughout many years of storm and calm alike.

Many diseases being prevalent in these times made it necessary to isolate them from the townsfolk, who exclusively used the adjoining parish Church of All Saints. The bodily needs of the pilgrims were catered for at the Abbey Almonry nearby which is still standing.

The Church had become sadly dilapidated and in 1730 an extensive and as it proved, disastrous reconstruction took place because owing to faulty construction and poor materials, the new roof collapsed before 1800.

The Church remained in ruins until 1837 when it was restored and reopened for divine worship in its present form.

In 1937 a further minor restoration took place.

In the west porch of St Lawrence's is an old information board full of errors. The first extant reference to St Lawrence's is dated 1195 (not 1295). In 1295 the church was reconsecrated (not consecrated). St Lawrence's was a parish church, not a church for pilgrims.

The east wall of St Clement's chantry, St Lawrence's, is entirely blank. The alignment of stones suggests a blocked doorway, perhaps where the church joined the abbey by a 'very great and curious walk' (as recorded by Thomas Habington (1560–1647)).

It seems clear, then, that Evesham had two churches because it had two parishes. But that begs a further question: 'Why two parish churches rather than one (or even none)?'

Many abbeys established a parish church in their immediate neighbourhood in order to get rid of parish duties. This allowed the abbey church to be reserved to the monks alone. Evesham Abbey was wealthy and important, a mitred abbey answerable to the Pope alone. The abbot sat in parliament, levied justice, and had licence to wear all the episcopal ornaments including mitre, ring, sandals and other insignia. The abbot, like all his peers, was also keenly interested in promoting his social status. In *Power, Profit and Urban Land* (1996) Eliassen and Ersland point out:

> Ecclesiastical lords such as Benedictine abbots were, perhaps, even more concerned with questions of status than were their secular counterparts, since reflections of their power could normally be expressed only in social terms; they were unable to exercise the naked

A very early sketch (*c.* 1680) of St Lawrence's viewed from the east. The chapel of St Katherine (demolished *c.* 1737) stands on the right.

power of military actions. To the Benedictine abbot, and to his lesser abbey officials, therefore, the reconstruction of abbey buildings, the consolidation of a geographically coherent estate around the abbey, and the development of an urban market centre at the core of the estate, most frequently at the gates of the abbey complex itself, must have been an important expression of the abbot's social and political standing to the local community and the wider aristocratic realm of the region.

So, why two parish churches? Because Evesham Abbey was rich, powerful, keen to keep the abbey church separate, and keen to publicly assert its status. Why two? Because two is better than one.

Incidentally, had these two parish churches not existed at the dissolution (1540) then Evesham Abbey might have been spared as were the abbey churches of Worcester, Tewkesbury, Pershore and Gloucester.

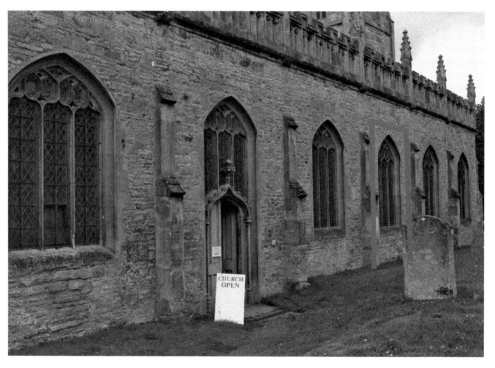

St Kathryn's Chapel (18 feet by 16 feet) stood off the north aisle immediately opposite the chantry of St Clement. Presumed location indicated in red.

# 10. Puzzles of the Bell Tower

Evesham's Bell Tower is so well known, and has stood for so long, that it might be thought that everything about this building must be known. There remain, however, some questions worth asking. Perhaps the most obvious question is: 'Why was there a detached bell tower?'

Some have argued that the bells had to be hung in a detached tower because of the risk that the abbey tower might collapse. After all, it had collapsed at least once before, in 1210, as recorded by Thomas of Marlborough (died 1236):

> ... the church tower collapsed and, apart from the shrines of St Ecgwine, St Odulf, and St Credan, which were miraculously saved, it crushed the presbytery and all the precious things inside it along with the shrine of St Wigstan and other shrines, with the high altar, tables, and other ornaments around it.

However, this cannot be the right reason, as we know from John of Alcester (1540) that the abbey tower contained bells, as did the Bell Tower:

> Ther were .v. bellys owere the quere and .vi. in the tower
> [There were five bells over the choir (of the abbey church) and six in the (bell) tower]

A separate bell tower might have been built to hold bells during the construction (or reconstruction) of the central abbey tower, or to accommodate bells of unusual size. Importantly, though, the Bell Tower also housed a clock and acted as a cemetery gate (Upper Abbey Park is the site of the old conventual cemetery). This last function is highly unusual. Indeed, among the known sixteen detached bell towers in Britain (lost and surviving) this function is unique. After all, it would be simpler, cheaper and structurally

DID YOU KNOW?
Dingley's early sketch (c. 1675) shows a central flag bearing the anchor emblem of St Clement. The flagpole was removed in 1717 and replaced by weathervanes on each corner pinnacle. If you closely examine an artistic re-imagining of Evesham Abbey, and it shows the neighbouring Bell Tower, these are subtle details to look for to see if the artist has done their homework. Incidentally, the Bell Tower once had a moon dial which marked the phases of the moon.

safer not to insert an archway through the base of a tower but, instead, to construct a separate archway to the north or south of the tower.

It seems clear, then, that Abbot Clement Lichfield built the Bell Tower as an expression of the abbey's wealth, status and importance. This wasn't a simple matter of glorifying the abbey (though that is surely true) but a way of glorifying God. Interestingly, the Bell Tower that stands today isn't the first detached tower built at Evesham, and probably not the first one on that site. There seems to have been something of a local tradition of building detached towers.

In 1319–20, William of Stow, sacrist, built or completed a new bell tower (*campanarium*). One source, however, records only that he gave twenty marks for repairing a bell tower and forty marks for improving the abbey tower. Thomas of Marlborough, when Prior of Evesham (*c.* 1218–29), gave more than one mark 'to the great bell tower (campanile) that Adam Sortes began'. In 1261 this new bell tower was struck by lightning. In 1278–79 an Evesham campanile was repaired, but this might have been either a detached bell tower or the abbey tower. Adam Sortes's bell tower was perhaps the campanile of which the greater part collapsed in 1291–92. Repairs or rebuilding took place in 1319–20. A new bell tower was built in the time of Abbot Roger Yatton (appointed 1379). The new bells were presumably larger and heavier, requiring a stronger structure. Yatton's tower was presumably replaced by the bell tower that stands today. In summary, then, over the centuries, there have been at least three (but perhaps four) campaniles serving Evesham Abbey.

Some scholars, contemplating the Bell Tower, have wondered if it was unfinished. William Tindal (1794) certainly thought so:

It was certainly the intent of the architect to have raised this building considerably higher. This is apparent not only from the general form of the tower, rather low in proportion to its breadth, but also from the flying buttresses; which are seldom, as in the present case, carried quite to the summit ...

I have been informed that this tower was left unfinished at the dissolution; and was not completely covered-in till long after that period. But besides that the ornaments on the top seem perfectly congenial to the rest of the fabric, the circumstance of the great bell, recorded by Leland ... appears entirely to overthrow this supposition. The probability is, that a foresight of the impending dissolution hastened its finishing, and thus prevented a farther progress in altitude.

DID YOU KNOW?
George May (1845): 'A custom somewhat peculiar and observed beyond memory till within the last two or three years was that of rising [sic] the tenor bell, which hangs in the bell tower, at 4 o'clock in the mornings of Monday, Thursday and Saturday, throughout the year.' Presumably this originally marked the divine office of Prime (at sunrise). But why retain this custom? Because this was also when trade could begin in the Market Place (meaning the Bell Tower was serving as a market bell).

A simple sundial scratched into a stone under the Bell Tower archway, where the sunlight cannot reach. Has this stone be repurposed? (Carmel Langridge)

DID YOU KNOW?
You will sometimes find the building of the Bell Tower (c. 1530) ascribed to Robert Vertue the younger (son of the master mason Robert Vertue (d. 1506) who worked on Westminster Abbey). This notion apparently arises from there being an Evesham monk named Robert Vertue who was master of works in 1540. This monkish Vertue seems to have been a career cleric, becoming chaplain at All Saints' (c. 1540) and later the vicar of Wickhamford (1563). However, there is nothing to connect this Evesham monk with the son of the mason Robert Vertue other than the curious coincidence of names.

If the Bell Tower was built around 1540 (that is, just before the dissolution of Evesham Abbey) then Tindal's suggestion might seem credible. However, the Bell Tower was completed around 1530. At that time there was no serious suggestion that any of England's great abbeys would be overthrown.

A number of writers have considered the 'completed-ness' of the Bell Tower, most famously George May (1845):

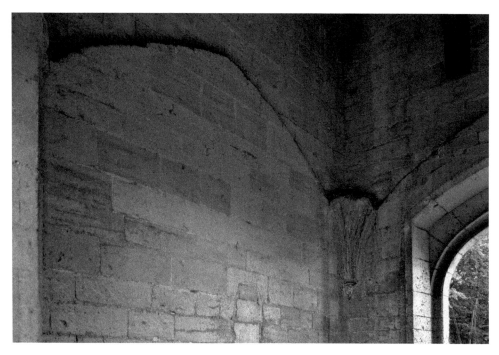

The ledge and carved springer (in the corner) clearly indicate that the original plan was to install a vaulted ceiling.

The insertion of the stairwell, obscuring one of the springers, would have made it deeply impractical to install a vaulted ceiling.

The uniform appearance of this structure, and the harmony of its design, annul a supposition which some have hazarded – that the work was either not completed by the founder, or else not carried up to the original elevation of his plan. A general survey will readily prove that any increase in its height would materially have impaired the present graceful outline of the whole. Indeed the only parts that apparently required perfecting when its founder resigned his dignity are a groined ceiling within the archway, of which the imposts [springers] only are raised, and the upper portion of the newel staircase, now supplied by dangerous-looking ladders. In fact, of all this abbot's works, the bell-tower seems to have been an object of his highest pride. He recorded its erection on the painted glass inserted by him in the great east window of the abbey choir, and repeated it upon the brasses of his tomb – imploring in both instances the supplications of the faithful on that account.

The presence of 'unfinished' springers clearly suggests that the original intention was to add a vaulted ceiling (like those in the nearby chantries of All Saints' and St Lawrence's). However, there is no such ceiling, so what happened?

One possibility is that a vaulted ceiling was indeed installed, but then removed during the general demolition of the abbey church. This possibility can be discounted as there are no chisel or hammer marks on the stone (that is, no evidence that a ceiling was removed). Furthermore, it is unclear why only a vaulted ceiling would have been demolished rather than the entire building. Most importantly, the insertion of a polygonal stairwell under the tower makes a vaulted ceiling impracticable.

Another possibility is that there never was a plan to construct a vaulted ceiling (in spite of the presence of springers). After all, at that period bells were hung stationary and struck by a clapper or hammer. Such an arrangement places very little strain on a building, meaning there is no need for the additional bracing provided by a vaulted ceiling. Indeed, wooden floors are arguably better suited for dealing with any movement resulting from the striking of bells.

So, if there was no vaulted ceiling, and no intention to install one, then why are there springers? The answer might lie in the fact that these springers are badly eroded, even though they are well protected from the weather. This simple detail suggests that they were reused from an earlier structure. This is not the only evidence of the reuse of stone. On the southern side of the Bell Tower archway is a scratch sundial. This might not seem odd as such makeshift sundials often appear on the walls of old churches. However, here the sundial faces north(ish) and is hidden from direct sunlight. The clear implication is that this stone (on which the sundial is scratched) comes from another building. Curiously, this stone is carved (re-carved?) perfectly for its current situation.

This line of speculation looks stronger when we consider the noticeably poor and heavily weathered quality of the stone in the lower plinths of the Bell Tower. The implication is not only that stone was reused, but that the present-day Bell Tower stands on the site as an earlier campanile. Chris Povey (2015), ringing master at the Bell Tower, has written that:

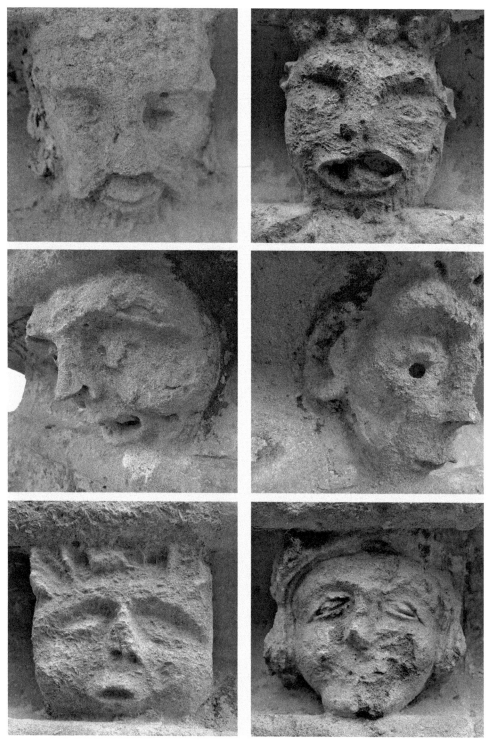

A selection of carved faces hide underneath the corbels (projecting ledges directing rainwater away from the building). Were they based on historical figures? (Author/Carmel Langridge)

The most stunning possibility concerns the lower plinth course and the masonry work inside under the archway. Why in Heaven's name is there such poor masonry work in the plinth course when above it there is magnificent work? There is evidence of previous towers on the site, so we now wonder – and we can only wonder without hard proof – whether the immediately-previous bell tower was taken down and the present tower built on its foundations. If the masonry of the previous tower was poor, then Clement Lichfield's imagination for a magnificent new tower would have been well and truly fired. If the old foundations were OK and there wasn't much on show, he could re-use them.

After considering the style of building, Revd M. Walcott (1876) proposed that the Bell Tower was built by Abbot Zatton (1379–1418). This is intriguing, as it begs a further question: 'When was the Bell Tower built (and how do we know)?'

Walcott's strongest argument was architectural; that the style of the Bell Tower more closely resembles that of earlier periods than the Tudor age. This observation echoes a similar comment by George May (1845):

The sacerdotal architect, in his construction of this tower, has with correctest taste, preferred the style of a preceding era, to the already debased manner of his own day: so that, in the absence of direct evidence to the contrary, its distinctive features might appropriate it to the reign of Henry the Sixth [1421–71].

This is all very intriguing, but wrong. The will of John Molder (1524) includes a bequest of 40 shillings 'to the said Monastery [of Evesham] to the building of a new Tower for their bells'. Two later wills, of William Roff of Evesham (1529) and Thomas Crompe of Bretforton (1530), bequeathed monies for the 'building of the new tower at Evesham'. Two even later wills, of Agnes Joyse of Hampton (1532) and Thomas Joyse of Hampton (1532), gave monies for the ringing of bells in the new tower. It is clear that the Bell Tower was built between 1524 and 1532.

There is also a curious carving above the east-facing archway of the Bell Tower: the now-eroded emblem of Abbot Clement Lichfield. This escutcheon shows an anchor together with the monogram 'CL' (Clement Lichfield). The anchor was not only a long-standing Christian symbol of faith, but also the sign of St Clement, who suffered martyrdom by having an anchor tied about his neck before being cast into the sea. When Clement Lichfield began his new life as a monk he chose a new name (the saintly one of Clement) and adopted the anchor symbol of his saintly namesake. Around the edge of the emblem is a phrase from 2 Corinthians 10:17: '*Qui gloriatur in Domino glorietur*' [But he that glorieth, let him glory in the Lord].

This escutcheon is not the only interesting carving on the Bell Tower. At the top of the quatrefoils, and below the various ledges, are many small carved faces. One of them is new: a carving of the face of the Bell Tower's long-serving ringing master, Chris Povey.

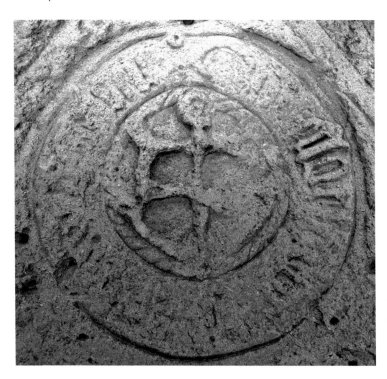

The anchor emblem of Abbot Clement Lichfield is carved above the east-facing archway of the Bell Tower.

The new carved face on the Bell Tower, memorialising Chris Povey.

Evesham /SF/15

Sketches made by Sam Findlay for the Bell Tower's newest carved face. (Chris Povey)

# 11. Why Did the Bell Tower Survive?

The Bell Tower, completed a decade before the dissolution, is the most obvious surviving link to the long-gone Evesham Abbey. Edmund New, writing in 1904, provides the following wonderful description:

> How dignified does the Bell Tower appear, with the twin [church] spires, rising from the summit of the bank, above the willows which edge the fish ponds! And below in the smooth waters their image is reflected, broken and clear at intervals. All the morning does the sun glorify the scene, and beneath its intense rays the towers gleam white against the blue heavens. Every third hour the bells in Lichfield's tower play an old tune fraught with sweet memories.
>
> The horses browse in the meadows or stand beneath the shade of the tall elms. Often a brightly-coloured caravan is to be seen encamped near the ponds, and beside it a fire which sends a faint cloud of blue smoke up against the dark green of the foliage. Out come the children to play on the green slope, to fish in the ponds or gather flowers in the meadow below.
>
> An old barge, perhaps, lies under the bank, towed up with much labour from the Severn. Pleasure boats pass now and again, disturbing the water and breaking the reflections into a thousand fragments.
>
> Evening comes on; the sun declines, and the face of the tower is dark against the glittering beams; the water receives the glow and reflects the radiance. Tower, spires, trees and landscape assume one sombre hue; clear cut against the sky their forms appear; and, as night falls, the single deep-toned bell rings out the 'Curfew' across the silent vale.

A lot has since changed. Horses no longer graze the meadows. Gypsy caravans no longer camp beside the river. The curfew bell no longer tolls at eventide. However, the Bell Tower still stands, as it has for so many centuries, at Evesham's ancient sacred heart.

We've considered the origin of the Bell Tower, its predecessors, whether it's finished, when it was built, and some detailed carvings. However, we've not yet contemplated perhaps the most important question: 'Why did the Bell Tower survive?'

The significance of this question becomes clear when we consider what little is left of Evesham Abbey (basically only the rebuilt Cloister Arch). The surviving magnificence of the Bell Tower stands in stark contrast to the utter devastation of the nearby abbey church.

There are, broadly speaking, three theories regarding the survival of the Bell Tower. The first one suggests that it was purchased by the town. This appears to have been first proposed by William Tindal (1794) who wrote about 'the townsmen who had purchased the tower'. This notion might have reflected an established local tradition. Writing in 1910, E. A. B. Barnard subscribed to this self-same view:

Speculative image of Evesham Abbey by Warwick Goble (1862–1943). The abbey tower should sport a spire.

The earliest known image of the Bell Tower is from detailed notes (*c.* 1675) compiled by Thomas Dingley (died 1695).

Various reasons have been adduced to account for the Tower remaining untouched during the general destruction which went on around it, and the most likely one is that the townspeople found sufficient money to satisfy the rapacity of the Commissioners and others, and that they were thus enabled to preserve intact a monument in the erection of which probably many of them had had a share.

George May (1845) dismissed this theory while proposing a second one:

> Dr Nash asserts, that this tower 'was purchased by the townsmen for their own uses, and thus escaped the general wreck of the dissolution'. The doctor's assertion appears, however, to rest upon a passage in Willis; where it has, confessedly, no better foundation than supposition. But, in the absence of any known document to the contrary, the probability is, that it was presented to the townspeople by Sir Philip Hoby, or his heirs: it being assuredly included in that sweeping clause of the royal grant, which conveys to the said Philip 'the house and site of the late dissolved monastery of Evesham; and all messuages, houses, pools, vineyards, orchards, gardens, land and soil, lying and being, as well within as without, and next and near the site, fence, compass, circuit and precinct of the same late monastery'.

Sir Philip Hoby initially made money by demolishing the abbey buildings and selling off the stone, but this represented only a short-term one-off gain. The townsfolk also made 'no little spoil' by taking goods and stone from the site. Sir Philip paid men to watch nightly to prevent further waste. Such local difficulties point to an uncomfortable relationship, at least initially, between Sir Philip Hoby and the town.

DID YOU KNOW?
The first band of ringers to ring a method have the right to propose its name. Geoff Hemming, ringing master (1947–84), was keen for a method to be named after Evesham. He contacted a Mr Tippler who sent him five never-rung methods. One was picked (one which looked the simplest) and an attempt was made at the Bell Tower on 30 January 1960 using eight bells (Evesham Surprise Major). One of the ringers, Roger Savory, pointed out that the newly named Evesham method could be extended to ten bells and to twelve bells: Evesham Surprise Royal and Evesham Surprise Maximus.

In order to exploit his rights and extract long-term returns from market rents and tolls, Sir Philip Hoby tried to enlist local support through local patronage. The most obvious example of this is the building (c. 1580) of the Town Hall. Given such generosity, it is easy to believe that he also gifted to the town the recently completed Bell Tower. The effectiveness of such measures is clearly demonstrated by an event in 1583. At this time Queen Elizabeth questioned certain rights exercised by Sir Edward Hoby (nephew of Sir Philip Hoby), including the right to control the courts of the town. The townsfolk

Abbot Clement Lichfield is sometimes (wrongly) claimed to have founded a grammar school. Instead, he endowed an existing (potentially very old) school with a new porch and (perhaps) schoolroom.

sided with the Hobys. Indeed, the misconduct of the pro-Hoby crowd almost ended in outright riot. In the longer term, however, this spat with the Crown proved damaging to the Hobys. In 1604 James I granted the town its first charter (replaced by a second one in 1605). Both royal charters altogether ignored and overruled the claim of the Hoby family (and their successors) to the overlordship of Evesham.

There is also a third theory: that around 1554 the Bell Tower was gifted to the town by Queen Mary I (reigned 1553–58). Indeed, this was reported in a declaration (c. 1553–54) relating to church lead and bells transferred between two former receivers of the Court of Augmentations:

> Evesham. In the Clok house ther one bell weiying by estymacion xxx$^{c}$ graunted by the Queene's ma$^{tie}$ unto the Towne ther.
> [Evesham. In the Bell Tower there is one bell weighing an estimated 300 lbs [probably] which was granted by the Queen to the town]

Strictly speaking, Queen Mary didn't grant the Bell Tower to the town, but instead gave to the town the sole surviving bell (housed in the Bell Tower). Perhaps that was enough, with the transfer of that one bell effectively transferring the entire building.

Which of these three theories is correct? It is impossible to tell. Perhaps none of them are right. Perhaps all. Perhaps the Hobys gave the Bell Tower to the town, with some payment received, with the remaining bell granted later by royal decree. Ultimately, we cannot know for sure why the Bell Tower survived, but it's wonderful that it has. After all, how dignified does the Bell Tower appear!

# 12. A Lost Bell of Evesham Abbey

There is an interesting postscript to the dissolution of Evesham Abbey. In the tower of the Church of Gloucester St Nicholas hangs a bell (the fourth) bearing the following inscription:

> Sancte Johannes Baptista ora pro nobis SL
> tempore Clementis Lichfield sacrista Robertus Hendlei
> fecit ma in honore Marie Magdalene

Translated into English, this reads:

> St John the Baptist; pray for us SL
> in the time of the sacrist Clement Lichfield, Robert Hendley
> made me in honour of Mary Magdalene

The inscription is remarkable for including an invocation (John the Baptist), plus a separate dedication (Mary Magdalene), the name of the bell founder (Robert Hendley), and the name of the patron (Clement Lichfield). That last detail links this bell to Evesham as Clement Lichfield was the penultimate abbot of Evesham Abbey.

There has been a lot of scholarly speculation regarding this bell. Revd. H. T. Ellacombe (1881), in *The Church Bells of Gloucestershire,* assumed the parishioners of St Nicholas's commissioned the bell from a Gloucester bell founder, and therefore presumed that Clement Lichfield was associated with the Church of St Nicholas. When H. B. Walters came to write *The Church Bells of Worcestershire* (1924–25) he thought Lichfield 'may have been sacrist of Gloucester Cathedral *(sic)* about 1480–1500'. When Frederick Sharpe (1975), in *The Church Bells of Herefordshire* ( vol. V), discussed this self-same bell he thought: '*it is possible* that he was the man who became the last Abbot of Evesham and built the campanile there: if so, he could have been sacrist of Gloucester Cathedral *circa* 1480–1500.'

A decade later this idea was repeated by Bliss and Sharpe (1986), in *Church Bells of Gloucestershire*, not as speculation but declaration: 'It is thought that the Clement Lichfield who was sacrist at Gloucester was the same Clement Lichfield who became the last Abbot of Evesham in 1514, having previously held several minor offices at the Abbey of Evesham.'

This is fascinating stuff, if only because of the way that repetition has turned tentative assumption into qualified certainty. There are, however, significant problems with these claims.

Parish churches typically did not have sacrists; instead, this was a job found at an abbey or cathedral. The Church of St Nicholas was linked to the Hospital of St Bartholomew from 1229 until the dissolution, at which point it passed to the City Corporation. There

The Bell Tower in stained glass in St Peter's (left) and in All Saints' (right). In the latter Abbot Clement Lichfield is holding a model of his famous tower.

IN LOVING MEMORY OF
HAROLD CHEETHAM DILLWORTH 1904-1980

was no connection between this church and Gloucester Abbey (now the cathedral). If Clement Lichfield had been sacrist of Gloucester Abbey, he would not have spent abbey resources commissioning a bell for an unrelated church. Moreover, if this bell was commissioned by the parishioners (as H. T. Ellacombe suggests) then the inscription ought to record the name of the Master of St Bartholomew's Hospital, or the chaplain, or a rich patron. Clement Lichfield could have been that rich patron, but if so, then why does the inscription include the job title of 'sacrist'?

Given all of the above, it seems clear that this bell was not cast for Gloucester St Nicholas. Perhaps, instead, it was cast for Gloucester Abbey but later found a new home in the church? This idea was considered by John Eisel in *The Church Bells of Breconshire* (2002):

> It has been suggested that the bell came from St Peter's Abbey, Gloucester (now Gloucester Cathedral), but this seems unlikely – we have no evidence to connect Lichfield with Gloucester, and a bill of sale exists for the purchase of four bells from St Peter's Abbey by the parishioners of Leonard Stanley in Gloucestershire. The tower of Gloucester Cathedral still contains medieval bells, and all the bells existing there at the Reformation [1529-1537] would seem to be accounted for.

So if this bell was not cast for Gloucester St Nicholas, and was not cast for Gloucester Abbey, then where did it come from? Based purely on the inscription mentioning 'Clement Lichfield', then Evesham Abbey must be the prime candidate.

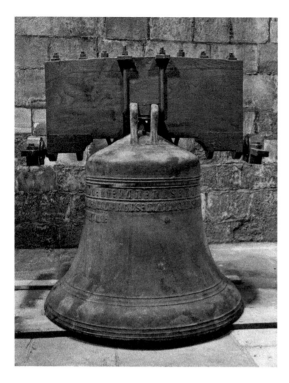

The fourth bell of Gloucester St Nicholas.
(Churches Conservation Trust)

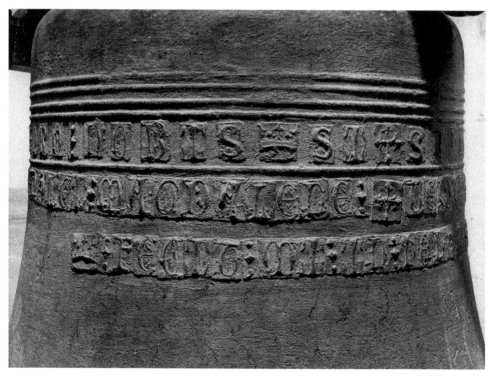

Part of the inscription on the fourth bell of Gloucester St Nicholas. (Churches Conservation Trust)

We know a fair amount about Clement Lichfield. He was born around 1470 and joined Evesham Abbey around 1490. He was ordained a priest at Frideswide's Priory, Oxford, on 23 September 1497. He was admitted as Bachelor of Theology (B.Th.) in 1500. He supplicated to be admitted as Doctor of Theology (D.Th.) on 16 November 1507. He probably studied at Gloucester College, Oxford, although from around 1430 to 1490 Evesham monk-students may have been sent to Canterbury College, Oxford. He was elected abbot in 1513, having previously served as prior. He resigned on or before 17 March 1538 (Old Style). He died on 9 October 1546 (Old Style) and was buried in his chantry chapel in All Saints' Church.

DID YOU KNOW?
In a marginal note the monk John of Alcester wrote: 'And in the year of Our Lord 1539 the monastery of Evesham was suppressed by King Henry VIII, the 31 year of his reign and the 30 January at evensong.' However, in 1752 England moved from the Julian calendar (i.e. Old Style) to the Gregorian calendar (i.e. New Style) and moved the start of the year from Lady Day (25 March) to 1 January. So when, in the modern calendar, was the suppression of the abbey? The 31 regnal year of Henry VIII ran from 22 April 1539 to 21 April 1540 (New Style); meaning the date of Evesham's dissolution is 30 January 1540.

There is no direct evidence that Clement Lichfield ever served as sacrist of Evesham Abbey. However, given everything else, it seems perfectly reasonable to believe that he started as a monk at Evesham Abbey, studied at Oxford, and then progressed through the abbey's lower offices (including as sacrist) until taking on its highest office. So, if Clement Lichfield only ever served at Evesham, and if he commissioned this particular bell, then what is this bell doing at Gloucester?

After the dissolution there was considerable trade in monastic bells. Many church towers were furnished with spoils taken from the monasteries. Notable local examples include bells from Winchcombe Abbey being taken to Stoneleigh (Warwickshire), a bell from Osney Abbey becoming the original Great Tom of Christchurch, Oxford, and the bells of Bordesley Abbey being bought for the parish church of Strensham. Generally only monastic bells were confiscated. The fourth bell of Gloucester St Nicholas probably experienced a similar story. John Eisel (2002) certainly thought so: 'since the bell was not cast for St Nicholas (a parish church did not have a sacrist) it may have been transferred there after Evesham Abbey was dissolved.'

If the fourth bell of Gloucester St Nicholas is indeed a lost bell of Evesham Abbey, cast for Abbot Clement Lichfield of Evesham, then arguably there is only one remaining question: 'Can we have our bell back, please?'

The building marked 'A' stands on the site of the bell barn, while the building marked 'B' is where the abbey's medieval great gateway once stood.

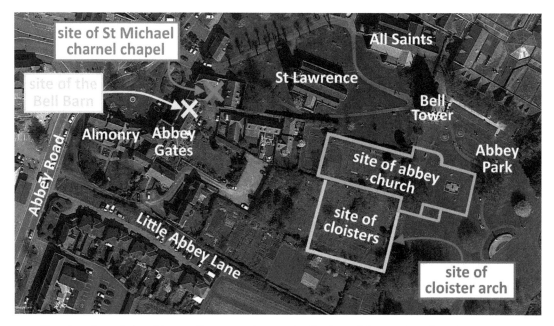

The site of Evesham Abbey, Bell Barn, and St Michael's charnel house chapel in the centre of Evesham. (Map data © 2018 Google)

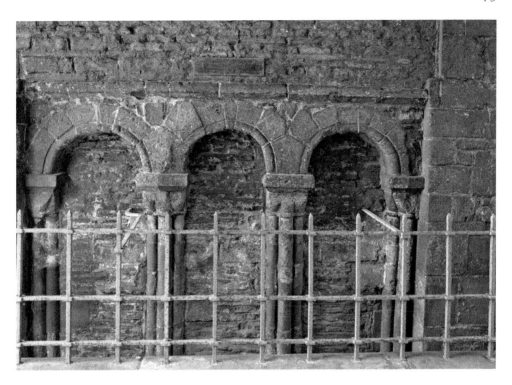

*Above*: Gateway connecting Market Place and the parish churchyard. Commonly called Abbot Reginald's Gateway (abbot 1130–49) or the Norman Gateway (from the Romanesque architecture).

*Right*: The Norman Gateway is some 2½ feet (29 inches) below the modern street level (which has slowly risen over time). The ledge supported the original first storey.

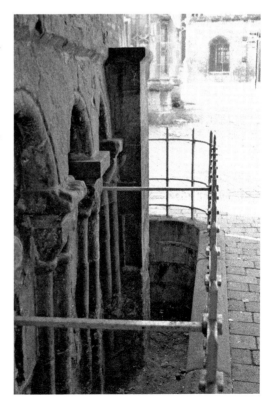

# 13. Tales from Shakespeare's Evesham

Bearing in mind the short distance from Evesham to Stratford-upon-Avon (some 15 miles), there is an excellent question to ask: 'Did William Shakespeare ever visit Evesham?'

According to local legend, and as told to me by my grandmother, the answer is 'yes'. The story concerns the origin of the name 'Shakespeare's Rest', a house on Four Corners (the junction of Cowl Street, Oat Street, Chapel Street and Mill Bank). The story says that William Shakespeare (1564–1616), perhaps on his way to Worcester to obtain a special marriage licence, stopped at Evesham for a rest. He is said to have sat on a horse mounting block at the top of Mill Bank. Another version of the story has Shakespeare staying overnight on his way to visit Bidford-on-Avon.

The Shakespeare's Rest (c. 1900) located at 'Four Corners' (locally once known as the 'Four Corners of Hell'). (VEHS)

It's a charming story, though very thin on detail. Sadly it's also quite a recent story. E. A. B. Barnard (1911) reports that the name 'Shakespeare's Rest' comes from a plate fixed on the house by an Evesham tradesman during the mayoralty of Mr J. S. Slater in 1901. So, did Shakespeare ever visit Evesham? Possibly, but we don't know. What we do know is that the name 'Shakespeare's Rest' is a bit of Victorian entrepreneurial marketing nonsense.

There is another and more intriguing story. In 1883 J. O. Halliwell-Phillipps privately published a paper titled 'The Fool and the Ice'. His starting point was a curious phrase in one of Shakespeare's plays: 'The fool slides o'er the ice that you should break' (*Troilus and Cressida*, Act III, Scene III, line 216). According to Halliwell-Phillipps:

> ... the imagery is so peculiar, it may be reasonably suspected that there is a reference to an extraneous story or incident which was in the author's mind at the period of composition. And if it can be shown that one of the latter alternatives is probable, the allegory cannot be received as an original fancy without the assumption of a very remarkable and

Did William Shakespeare ever visit Evesham? Was he inspired by the Dissolution of the Monasteries? Engraving by George Vertue (1684–1756).

unlikely coincidence. When, therefore, it is found that there happened, in the poet's own day and at a short distance from his native town, a somewhat remarkable event to which the line spoken by Ulysses could perfectly apply, we may conclude that Shakespeare was either present on the occasion or was familiar with its details.

What was the event? In simple terms, sometime before August 1600 the touring theatrical company of Lord Chandos of Sudeley, which had been performing at Evesham, prepared to move on to Pershore. A certain local called Jack Miller, apparently a natural imbecile, was much impressed by the company's clown and decided to follow him on his travels. Jack Miller therefore ran over the thinly iced river, and with perfect safety. This event was witnessed by a certain Robert Armin, afterwards a professional colleague of Shakespeare. Armin subsequently collected together a set of such unusual tales, publishing them in 1605 with the title *Foole upon Foole* or *Six Sortes of Sottes* (under the pseudonym 'Clonnico del Mondo Snuffe', which means the clown of the Globe Theatre). In 1608 he re-edited the work and published it under his own name and under a new title, *Nest of Ninnies*:

In the town of Esam [Evesham], in Worcestershire, Jack Miller being there born, was much made of in every place. It happened that the *Lord Sandys'* players came to town and played there; which Jack not a little loved, especially the clown, whom he would embrace with a joyful spirit, and call him *Grumball*, for so he called himself in gentlemen's houses, where he would imitate plays, doing all himself king, gentleman, clown and all; having spoken for one, he would suddenly go in, and again return for the other; and, stammering as he did, make much mirth: to conclude, he was a right innocent without any villainy at all.

When these players I speak of had done in the town, they went to Partiar [Pershore], and Jack swore he would go all over the world with *Grumball*. It was then a great frost newly begun, and the Avon was frozen over thinly; but here is the wonder: the gentleman that kept the Hart [on Bridge Street, near the Crown], an inn in the town whose backside looked to the way that led to the river-side to Partiar [Pershore], locked up Jack in a chamber next to the Avon, where he might see the players pass by; and they of the town, loathe to lose his company, desired to have it so.

But he, I say, seeing them go by, creeps through the window, and said '*I come to thee, Grumball*'. The players stood all still to see further. He got down very dangerously, and makes no more ado, but ventured over the Avon, which is by the long bridge, as I guess some forty yards over; yet he made nothing of it, but my heart asked when my ears heard the ice crack all the way.

When he was come unto me I was amazed, and took up a brick-bat [i.e a piece of brick], which lay there by, and threw it, which no sooner fell upon the ice but it burst. Was not this strange that a fool of thirty years was borne of that ice which would not endure the fall of a brick-bat?

But every one berated him for the deed, telling him the danger. He considered his fault, and, knowing faults should be punished, he entreated *Grumball* the clown, whom he so dearly loved, to whip him but with rosemary, for that he thought would not smart. But the players in

jest beat him till the blood came, which he took laughing, for it was his manner ever to weep in kindness and laugh in extremes. That this is true mine eyes were witnesses, being then by.

It's a fascinating story, but it does not in any way prove that Shakespeare visited Evesham. This is a shame because Evesham, as a tourist destination, would certainly benefit from tapping into the massive tourist interest in Stratford. There is, however, a definite problem as regards marketing. While Stratford is widely known, with full justice, as 'Shakespeare's Stratford', perhaps there is little appeal in tagging Evesham as 'the town just next door(ish) to Shakespeare's Stratford'.

At the apex of the roof of the Walker Hall is the carved monogram of Thomas Newbold (abbot 1491–1514).

# 14. Enigmas from Victorian Evesham

## Britain Street

It is a little-known fact that Brick-Kiln Street was originally called Britain Street. E. A. B. Barnard (1932) commented that Britain Street was 'now wrongly called Brickiln Street'. E. J. Rudge (1820) recorded 'Bricken or Briton-street, called formerly Brutstrete or Brutayne-street'. Earlier records mention Brittaine Street (1657), Brittayne-street (1584), and Britten Street (1546).

All these names are intriguing as, ultimately, they derive from the Anglo-Saxon 'Brytten' (meaning British). In the long-discredited mythological history of Britain, the first king was Brute or Brutus (which, sadly, in Latin mean 'heavy or stupid'). That such a name was used, marking a specific ethnic type, strongly suggests a long-maintained split between the Celtic/British and Anglo-Saxon settlers.

## Capon Pot Lane

Old documents sometimes mention Capon Pot Lane. The earliest reference (at least that I could find) dates from 1576, with the name popping up occasionally in the centuries that follow (1654, 1820, and 1840). The name is no longer in use, so where was Capon Pot Lane?

Local historian George May thought it was an early name for the modern-day Chapel Street. He was living in the town when he wrote his histories (1834 and 1845) so he should have known what he was talking about. The name Chapel Street dates from the building of a new Methodist chapel (since replaced by a county school, now a carpark) and documents relating to this work (c. 1808) called the street Capon-lane.

DID YOU KNOW?
In the 1850s a circus was crossing the old bridge. Unfortunately the elephant wagon (drawn by several horses) got severely stuck as the bridge was very narrow (like the old bridge at Pershore). Extricating the wagon left the bridge damaged and dangerously cracked. In 1854 an old woman was crushed to death by a passing wagon; clearly a new bridge was required.

However, there is also evidence, arguably stronger, that Capon Pot Lane was an early name for Avon Street. E. J. Rudge (1820) thought Capon Pot Lane was a continuation of Magpie Lane (the old name for Avon Street). As an important local landowner, he also

81

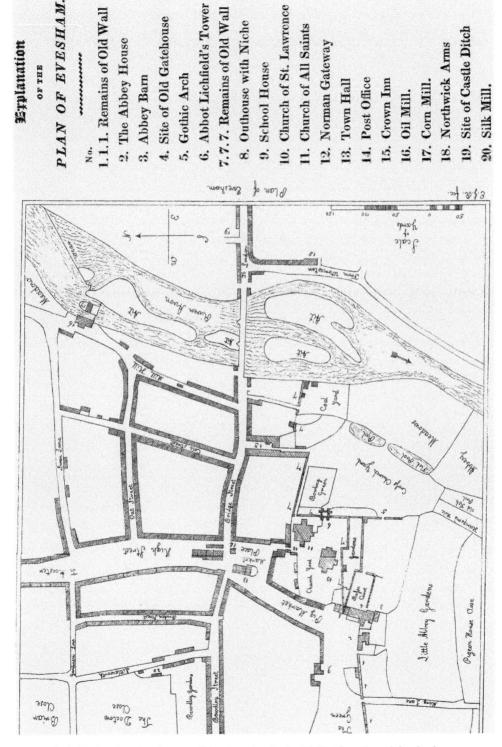

E. J. Rudge's fascinating sketch map of Evesham (*c.* 1827) with 'Bricken Street' clearly shown.

should have known what he was talking about. An 1840 map clearly places Capon Pot Lane on the site of the current Avon Street. Also, oddly, George May (in both his 1834 and 1845 histories) records a particular bequest, which reads: '*Two-and-sixpence* per annum, out of Caponpot-lane, between Briar close and the Doctor's close; payable to the parish of All Saints [so could be Avon Street].'

So where was Capon Pot Lane? Well, either it's an early name for Chapel Street (possible), or an early name for Avon Street (probable). Perhaps both? Can we know for sure? Perhaps future research will provide better evidence to provide a better answer?

## Muzio Clementi

Muzio Filippo Vincenzo Francesco Saverio Clementi (1752–1832) had a long and important musical career. This Italian-born English composer tutored students, provided musical entertainment, manufactured pianos, published scores and edited music (including harmonic 'corrections' to selected Beethoven scores). Ludwig van Beethoven (1770–1827) had the highest regard for Clementi. Indeed, he apparently considered Clementi's sonatas 'the most beautiful, the most pianistic of works, both for their lovely, pleasing, original melodies and for the consistent, easily followed form of each movement.'

The inscription upon Clementi's grave, in the cloisters of Westminster Abbey, proclaims him 'The Father of the Pianoforte'. It also records that he was 'Born at Rome 1752' and that he 'Died at Evesham 1832'. But where (exactly) in Evesham? For quite some time there

Muzio Clementi, famous pianist and composer, died at Evesham in 1832.

Two brothers, William and Henry Smith, founded the Evesham printers W&H Smith. An early office was at the top of Bridge Street. (VEHS)

The London stationers WHSmith was founded by William Henry Smith (1792–1865). Oddly their Evesham shop occupies the old Journal buildings of (the unrelated) W&H Smith.

was no clear answer. Then, in 1911, local historian E. A. B. Barnard received a note from Miss Myra Taylor, of Evesham, which happily addressed this question:

I think that I am in a position to tell you that it really was at the Elm (the house now in the occupation of Mr A. Kendall) that Clementi died. I remember that in course of conversation with an old laundress, M.W., employed by us, I found that she was living at The Elm in 1832 as a young housemaid, so I questioned her about Clementi. Her reply was that she could not remember the name, but quite well remembered an old *'I-talian'* suddenly dropping down dead in the laundry there, and that his body was afterwards taken to London. From what she said I gathered that he was staying at the house as a visitor, so I do not think that he rented it himself.

# 15. Alternative Eveshams

There is more than one place called 'Evesham'. In 1919 a small settlement in Saskatchewan, Canada, was incorporated as 'Evesham'; the name was apparently selected at random by an official of the Canadian Pacific Railway. There are also two homesteads called 'Evesham' in Australia, one is in Queensland and the other in New South Wales. However, perhaps the most intriguing 'alternative Evesham', at least for me, is a township in New Jersey, USA. William A. Starna, in *From Homeland to New Land* (2013), sets the American scene:

> An important outcome of these negotiations was the establishment of the Brotherton Indian Reservation in Evesham Township, Burlington County, New Jersey, in August of that year [1758]. John Brainerd was appointed reservation superintendent and guardian in 1762. According to historian C. A. Weslager, 'the place-name of Brotherton', bestowed on the reservation in 1759, 'apparently was selected by Governor Bernard to connote brotherliness, although he gave no reason for the choice.' Although Brotherton initially was home for between two hundred and three hundred Delawares, by 1774 there were only fifty or sixty persons remaining.

New York State historical marker (erected 1935) of a road used by, among others, the Brotherton Indians. (M. T. Bradley)

The curiosity here is an apparent coincidence. In the English Evesham, since at least 1700, there have been folks bearing the surname 'Brotherton'. In the American Evesham, founded in 1672, the Lenni Lenape tribe was known as 'Brotherton Indians'. Coincidence? Possibly. Maybe not. Certainly an historical curiosity.

## Tolkien's Evesham (Not Quite Middle Earth)

John Ronald Reuel Tolkien, known as J. R. R. Tolkien, is internationally famous as the author of the extraordinary fantasies *The Hobbit* and *Lord of the Rings*. These stories, set in the fantastical Middle Earth, are full of elves, orcs, ogres, dragons and hobbits. Are they pure fantasy? Mostly yes, but not completely, as Tolkien himself explained:

> I am historically minded. Middle-earth is not an imaginary world ... The theatre of my tale is this earth, the one in which we now live, but the historical period is imaginary. The essentials of that abiding place are all there (at any rate for inhabitants of N.W. Europe), so naturally it feels familiar, even if a little glorified by the enchantment of distance in time.

Bearing this in mind, it is fascinating to note that Tolkien had a connection with Evesham (in Middle England). The family of Tolkien's mother, Mabel Suffield, lived in Evesham for generations. Furthermore his brother had a fruit farm in Blackminster, which Tolkien would visit by car (a Morris Cowley nicknamed 'Jo'). Tolkien certainly felt at home in Worcestershire, as he explained in a letter dated 18 March 1941: 'Though a Tolkien by name, I am a Suffield by tastes, talents, and upbringing, and any corner of that county [Worcestershire] (however fair or squalid) is in an indefinable way "home" to me, as no other part of the world is.'

Humphrey Carpenter, biographer of Tolkien, expands on this point:

> The Tolkiens always liked to tell stories that gave a romantic colouring to their origins; but whatever the truth of those stories the family was at that time of Ronald's childhood entirely English in character and appearance [the surname is German], indistinguishable from thousands of other middle-class tradespeople who populated the Birmingham suburbs.
>
> In any case Ronald was more interested in his mother's family. He soon developed a strong affection for the Suffields and for what they represented. He discovered that though the family was now to be found chiefly in Birmingham, its origins were in the quiet Worcestershire town of Evesham, where Suffields had lived for many generations.
>
> Being in a sense a homeless child – for his journey from South Africa [where he was born] and the wandering that now began gave him a sense of rootlessness – he held on to this concept of Evesham in particular and the whole West Midlands area in general as being his true home.

Many scholars (amateur and otherwise) have tried to establish clear connections between Tolkien's fantasy lands (especially the Shire, homeland of the Hobbits) and actual locations, topography, and customs in the Vale of Evesham and neighbouring Cotswolds. Tolkien addressed this question in a letter from 1956:

There is no special reference to England in the 'Shire' – except of course that as an Englishman brought up in an 'almost rural' village of Warwickshire [sic] on the edge of the prosperous bourgeoisie of Birmingham (about the time of the Diamond Jubilee!) I take my models like anyone else – from such 'life' as I know.

So, there is a connection, but according to Tolkien himself it's a vague one. While this might be broadly true, there are some direct links. Famously Tolkien took the name of Bilbo's iconic hobbit-hole ('Bag End') from the name of his Aunt Jane Neave's tumbledown manor house in Dormston (11 miles north of Evesham and not far from Inkberrow).

Other places in Tolkien's fictional world are likely to have been inspired, if only in a general sense, by actual locations. The 'Prancing Pony' in Bree might be based on 'The Bell Inn' in Moreton-in-Marsh. The 'Three Farthing Stone' (near the centre of the Shire) might have originated with the Four Shire Stone not far from Moreton-in-Marsh. Tolkien's fictional settlement 'Buckland' shares its name with a village on the Cotswold Edge (2½ miles south-west of Broadway). A curiosity of the Shire is the cultivation and smoking of tobacco ('pipe-weed'). Oddly enough, at least in the seventeenth century, Evesham was well known for growing tobacco.

So if the Vale of Evesham was indeed the original inspiration for Tolkien's Shire, then it's not the Vale here-and-now, but the Vale in some imaginary there-and-then. Irrespective of specific connections, it seems clear that Tolkien's Shire was (broadly speaking) inspired by Evesham, and the Vale, and the Cotswolds, and Worcestershire, and the English Midlands. If the Shire does indeed have any direct equivalent in the real world, then surely it's the Vale of Evesham.

If the Vale was the model for the Shire, then what of the hobbits who lived there? In his prologue to *The Fellowship of the Ring* (the first part of *Lord of the Rings*) he provided the following description:

Hobbits are an unobtrusive but very ancient people, more numerous formerly than they are today; for they love peace and quiet and good tilled earth: a well-ordered and well-farmed countryside was their favourite haunt. They do not and did not understand or like machines more complicated than a forge-bellows, a water-mill, or a hand-loom, though they were skilful with tools ...

As for the Hobbits of the Shire, with whom these tales are concerned, in the days of their peace and prosperity they were a merry folk. They dressed in bright colours, being notably fond of yellow and green; but they seldom wore shoes, since their feet had tough leathery soles and were clad in a thick curling hair, much like the hair of their heads, which was commonly brown ...

Their faces were as a rule good-natured rather than beautiful, broad, bright-eyed, red-cheeked, with mouths apt to laughter, and to eating and drinking. And laugh they did, and eat, and drink, often and heartily, being fond of simple jests at all times, and of six meals a day (when they could get them). They were hospitable and delighted in parties, and in presents, which they gave away freely and eagerly accepted ...

Hmmmm...

J. R. R. Tolkien was very proud of his English ancestors, the Suffields, who came from Evesham. This gravestone, in All Saints' Church, records three generations of Suffields.

A version of Tolkien's fictional town of Hobbiton was built in New Zealand for Peter Jackson's famous film trilogies. Was the real-life inspiration the Vale of Evesham?

## Evesham as Archer's Country

The long-running radio soap opera *The Archers* first aired in 1950 on the BBC Light Programme, then broadcast on the BBC Home Service, and then on BBC Radio 4. Originally billed as 'an everyday story of country folk', the show was initially conceived as a way to share information with farmers and smallholders during a post-war period marked by food shortages and rationing.

The fictional setting of *The Archers* is the village of Ambridge, near the market town of Borchester, not far from the cathedral and university city of Felpersham, in the English county of Borsetshire. But is there a real-world equivalent to these fictional places?

Godfrey Baseley, creator of the show, was born in Worcestershire at Alvechurch (22 miles north of Evesham). This simple fact means that Worcestershire has the strongest claim to being the original 'Archers' Country'. So, if the show was inspired by Worcestershire, then which real world locations might be the originals for Borchester and Felpersham?

If we ignore the details of cathedral and university, then Felpersham might be Evesham. After all, Evesham had an abbey and has a college of further education. This is vaguely close, but not really convincing.

If we take seriously that Felpersham has a cathedral and university, then Worcester must be the model for Felpersham. In this case, Borchester might be Droitwich Spa, or Malvern, or Pershore, or Evesham. Borchester is described as an historic market town with a leisure centre, graffitied bandstand, garden centres, a church dedicated to All Saints, is twinned with a German town, and the Town Hall has poor acoustics. So far, so Evesham.

However, it is not a perfect fit (inevitably). Borchester also has district council buildings, a homeless shelter, a multiplex cinema and a poodle parlour. Evesham has none of those (admittedly, to the genuine relief of some residents). So, probably, Borchester is a composite with multiple local inspirations. Whatever the ultimate judgement, if Worcestershire is the original Borsetshire, then surely the fictional Borchester is heavily inspired by the real-life Evesham.

## A Little Touch of Harry Potter

Evesham is briefly mentioned in J. K. Rowling's *Harry Potter and the Deathly Hallows*. In this book Mary Cattermole, from a wizarding family mixing the magical and the muggle, gives her address as 27 Chislehurst Gardens, Great Tolling, Evesham. While it's always lovely to see 'Evesham' mentioned, if only in passing, it must be acknowledged that there is no such street in the town, nor any such estate or village. It's a fine if trivial oddity, and perhaps a future historical oddity. Perhaps one day Evesham will indeed have a housing development named 'Great Tolling' containing a road called 'Chislehurst Garden'. In that speculative future perhaps someone will ask: 'But why is it called that?'

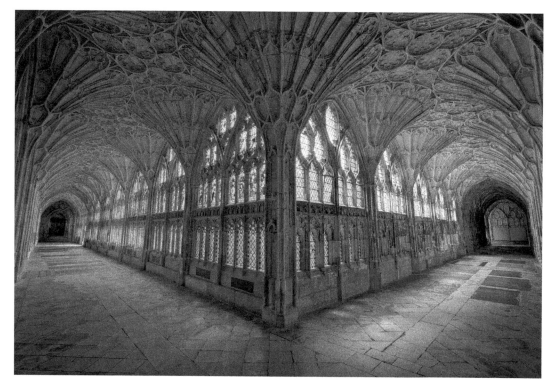

The cloisters of nearby Gloucester Cathedral were used in the Harry Potter films. Incidentally, did Evesham's cloisters look like this? (Michael D. Beckwith)

# 16. Selected Curiosities

Selected images of some small curiosities you might see when walking around the town.

Detail at the bottom of the chancel stained-glass window in St Andrews's showing the Workman Bridge.

In the 1600s Evesham was famous for strong shire horses. This pub sign commemorates one such breed (now lost).

*Above left*: This niche at the top of Bewdley Street appears to be a mounting stone for a gate hinge (later chiselled out and patched), perhaps used to control access to the town's market.

*Above right*: Sign above the High Street Mini Market. In 1872 the Wood Norton estate was bought by the Duc d'Aumale, fourth son of the King of France and pretender to the French throne.

Following significant repairs (1935) this stone was put over the door of the Royal Oak (Vine Street) to bear the name of the inn. Local sculptor Fred Cox found himself unable to complete the work because of an infirmity of the hands.

Side wall (Oat Street) of Amber Café, formerly the Clifton Cinema, itself formerly the Scala. This old name was chipped out of the stonework (above) but, with a little help, can still be made out (below).

*Above left*: Sculpted head of Hermes on the side of the old post office (Market Place).

*Above right*: The sign of the Cross Keys (High Street) marking out this building as an old inn.

In 1977 Evesham was twinned with Dreux (France), the traditional birthplace of Simon de Montfort.

In 1982 Evesham was twinned with Melsungen (Germany) and in 1989 with Evesham (New Jersey, USA).

# Acknowledgements

Many thanks to the Vale of Evesham Historical Society (VEHS) for permission to use materials from their archives. Thanks to Carmel Langridge and Revd Andrew Spurr for permission to use selected photographs. Thanks to Chris Povey for the sketches of the new Bell Tower carving. Thanks to the Churches Conservation Trust for permission to reproduce their images of the fourth bell of Gloucester St Nicholas.

Thanks to Revd Andrew Spurr for permission to take photographs of the interior of All Saints' Church. Thanks to the Churches Conservation Trust for permission to take photographs of the interior of St Lawrence's Church. Thanks to the Revd Mark Binney for permission to take photographs of the interiors of St Peter's Church (Bengeworth) and St Andrew's Church (Hampton).

Thanks to Dr Della Hooke (University of Birmingham) for permission to use selected images from her book *Worcestershire Anglo-Saxon Charter Bounds* (Woodbridge: Boydell Press, 1990). Thanks to Dr David Cox for permission to make use of his plan of the conjectured site of the Anglo-Saxon minster from his book *The Church and Vale of Evesham, 700–1215: Lordship, Landscape and Prayer* (Woodbridge: Boydell Press, 2015).

The image of the New York State historical marker is by M. T. Bradley and is licensed under the Creative Commons Attribution-Share Alike 3.0 Unported license. The photograph of the cloisters of Gloucester Cathedral (taken 23 May 2016) is by Michael D. Beckwith and is public domain. All other images are either public domain, out of copyright, or by the author.

Select Bibliography:
Bond, C. J., 'The estates of Evesham Abbey: a preliminary survey of their medieval topography', *Vale of Evesham Historical Society Research Papers*, vol. IV (1973)
Cox, D. C., 'The Tomb of Simon de Montfort: An Enquiry', *Transactions of the Worcestershire Archaeological Society*, third series, 26 (2018)
Cox, D. C., 'The Building, Destruction, and Excavation of Evesham Abbey: a Documentary History', *Transactions of the Worcestershire Archaeological Society*, third series, 12 (1990)
Sayers, Jane, and Leslie Watkiss, *Thomas of Marlborough* (Oxford: Clarendon Press, 2003)
Walcott, M., 'The Mitred Abbey of St. Mary, Evesham', *Proceedings of the British Archaeological Association* (March 1876)

# Closing Thoughts

This book has paid particular attention to ancient origins, the name of the town, Evesham's long-lost abbey, the strangely surviving Bell Tower, the ancient churches and idiosyncratic local legends. Why? Because the further back in time we go, the greater the scope for secrets, curiosities, mysteries, mistakes, fantastical legends and just plain old oddities.

Some subjects have not been covered; most obviously stories of the supernatural. Evesham has many ghost stories. Indeed, from a certain point of view, the Legend of Evesham is itself a ghost story. There is also the pious vision of the eleventh-century monk Sperckulf who saw:

> ... a mighty procession of holy spirits arriving ... All these were clad in white stoles, a wonderful sight to behold. At the end a person in bishop's robes arrived, of whom it could be said he was crowned with a wonderful loveliness, and was escorted on his left and his right by two elders adorned in similar garments. They approached the altar of St Ecgwine, and standing by it with great humility, they began the office of Matins, when the service had been brought to an end with great honour, one of them made preparations to sing Mass. *How wonderful was this vision!*

Later centuries reported less pious ghost stories. For example, in 1898 a ghost without feet apparently appeared to a Bengeworth stationmaster. No feet? Perhaps the ghost was walking where the ground used to be? There are also more recent ghost stories. On Christmas Eve 1999, for example, the staff at PriceLess Shoes (in the Alley) had constant troubles: alarms went off, footsteps were heard overhead, boxes were thrown about, items left in one place turned up in another. All very intriguing, but tricky to assess.

There is clearly significant scope for further research, for unearthing little-known stories, recording the unusual, investigating the odd, and hunting out the unexpected. Since the foundation of Evesham Abbey (*c.* 700) the town has grown dramatically, most especially over the last 100 years. As the town grows, as the future unfolds, so grows the scope for curiosities, mysteries and secrets. Good hunting!